The Best New

ANIMATION DESIGN

First published in the United States of America by:
Rockport Publishers, Inc.
146 Granite Street
Rockport, Massachusetts 01966-1299
Telephone: (508) 546-9590
Fax: (508) 546-7141

Distributed to the book trade and art trade in
the United States by:
North Light, an imprint of
F & W Publications
1507 Dana Avenue
Cincinnati, Ohio 45207
Telephone: (513) 531-2222

Other Distribution by:
Rockport Publishers
Rockport, Massachusetts 01966-1299

ISBN 1-56496-166-4

10 9 8 7 6 5 4 3 2 1

Art Director: Lynne Havighurst
Design/Layout: Judy Arisman, Arisman Design
Cover Photographs: *(Front Cover)*
 Page 6
 (Back Cover, top to bottom)
 Pages 68, 24, 34

Printed in Hong Kong

The Best New
ANIMATION DESIGN

ROCKPORT PUBLISHERS, ROCKPORT, MASSACHUSETTS
DISTRIBUTED BY NORTH LIGHT BOOKS, CINCINNATI, OHIO

INTRODUCTION

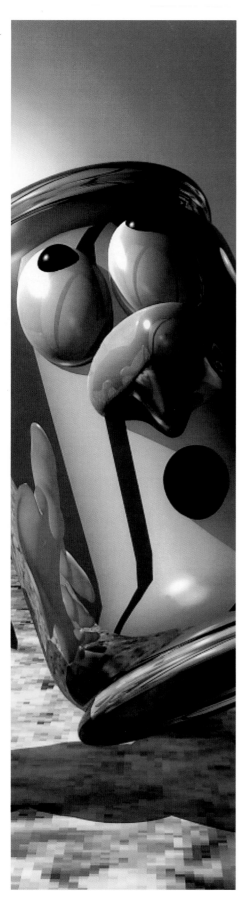

I love animation, all animation. Clay animation, stop motion, sand on glass, Xerography, scratch-board, computer animation, Disney animation I can't get enough. I rail against anyone who says animation is second rate compared to live action. And, I laugh at anyone who thinks watching cartoons is a waste of time.

Animation breeds passion, in its fans and in its artists. The reason for the fervor of a fan seems obvious, but why would anyone spend hours upon hours, days upon days, even years upon years, to create a cartoon that might only last seven minutes? The answer can only be passion.

When I think of the passion of animators, I picture John Kricfalusi, the creator of *The Ren & Stimpy Show*, jumping out of his chair to act out a scene for a new character, hair flying over glasses, lanky arms and legs swinging. Or animator Tom Sito, Head of Story for Walt Disney's *Pocahontas*, doodling on a scratch-pad over dinner doodles, the likes of which any collector would die for, which are quickly crumpled and thrown away to make room for more.

I imagine Chuck Jones, Bob Clampett, and Tex Avery working into the night at Termite Terrace, the tongue-in-cheek name they gave to their unit of the Leon Schlesinger studio hidden away on the back lot of old Warner Bros. From within the walls of that shabby little working space came the likes of Bugs Bunny and Daffy Duck and all the other Warner Bros. icons we love today.

When I think of those enthusiastic artists, I imagine the pranks they played on each other, the silly home movies they made at Christmas, and the free-wheeling atmosphere that reigned in spite of the fact (or because of the fact) the country was devastated by the Depression and soon embroiled in World War II. And, I picture Tex Avery yelling from his poorly lit desk, "Hey fellas! How 'bout this?" Sleepy eyes peering over his shoulder and lighting up as he acts out a gag. Heads thrown back with laughter. Imitations of silly cartoon voices filling the air. An impromptu dance of celebration. Backs being slapped and hands being shaken. Then just as suddenly as the raucous begins, a breath of silence like a double take between Porky and Daffy as each artist looks at the other and then makes a mad dash back to his desk to set the idea to paper.

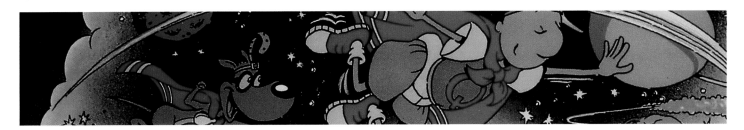

Animation is passion and sheer fun, but it can also be drama and tragedy and many other unexpected things. It is the forces of life and the universe as depicted in the works of American independent animator Faith Hubley. It is the pathos and humor of every day life as drawn by British independent Candy Guard.

As you will see by merely running your fingers through this marvelous compilation, another definition for animation is "variety." Animation is no longer thought of as just the Warner Bros. or Walt Disney styles. No, the term animation refers to the creation of movement frame-by-frame and applies to "The Lion King" as aptly as it does to flying logos and wire removals. Animation has found its way into every corner of entertainment, from Nintendo and Sega to special effects in virtually all feature films. The sciences (astronomy, oceanography, medicine) and practical arts like architecture and law use animation for the purposes of visualization. Even the United Nations Children's Fund, UNICEF, has discovered the power of animation and is beginning to use cartoons to communicate human rights issues around the world.

Animation is the future. Via a home computer center, your animated dog will deliver your digital newspaper, morning mail, and requested information off the Information Highway. Computer animation will create entertainments for the hologram arenas and virtual-reality theaters of the future. Animation will be a part of our everyday lives but, whether it will be called animation at that juncture is the topic for another essay.

No matter how it is defined or where it may take us, animation is nothing if not inspiring. The Publisher's at Rockport and I hope that you will use the images in this book for your inspiration. Keep this volume on a shelf close to your work for the moments when you need a little jolt of passion. Thumb through its pages whenever you need a reference for "variety." Keep it at the ready for the next time some pessimist proclaims, "There is no future in the arts."

Hand the rascal this book as proof to the contrary. The art of animation, art in general, is the future!

Enjoy!

Rita Street

Rita Street is the former Publisher/ Editor-in-Chief of Animation Magazine *and the Founder of the professional organization,* Women In Animation. *Street resides in Los Angeles, California and works as a freelance writer specializing in the animation industry.*

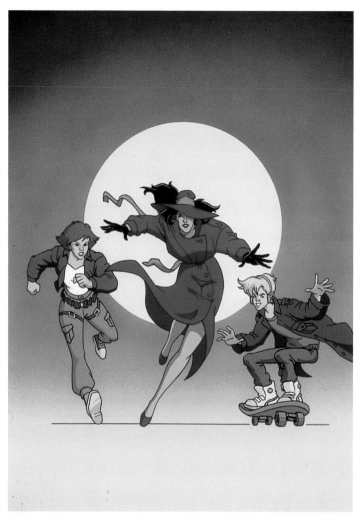

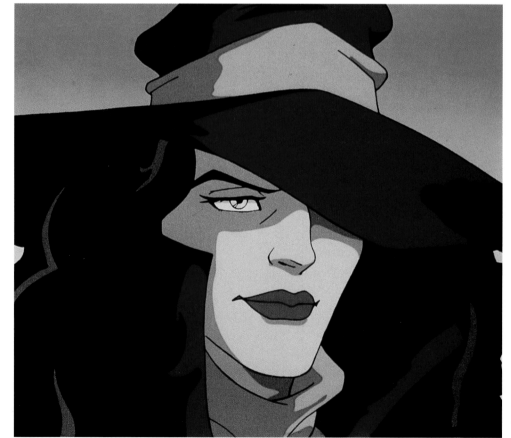

1-3
Where on Earth is Carmen San Diego, television series
STUDIO
DIC Entertainment
DESIGNER
DIC Entertainment
SUPERVISOR/DIRECTOR
Joe Baruso
Traditional cel and digital animation.

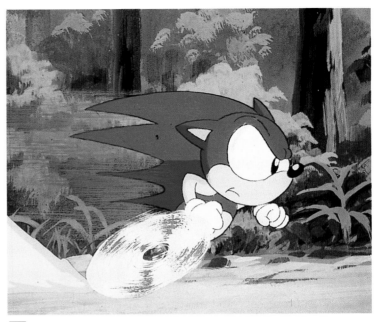

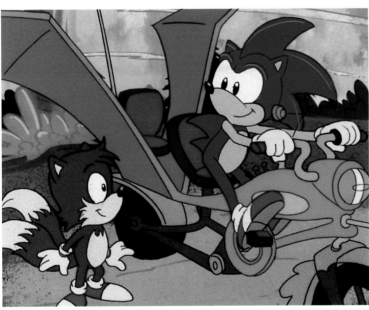

4-5
**The Adventures of The Sonic Hedgehog,
television series**
STUDIO
DIC Entertainment
DESIGNER
Sega of America
SUPERVISORS/DIRECTORS
Dick Sebast, Ken Butterworth
SUPERVISOR
Antran Manoogian
Traditional cel animation.

6
Snake Theatre, short film
STUDIO
Aaron Smith & Will Panganiban
DESIGNERS
Aaron Smith & Will Panganiban
DISTRIBUTOR
Expanded Entertainment
Traditional cel animation.

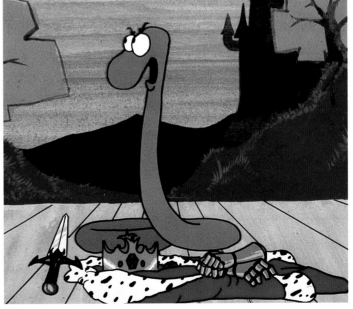

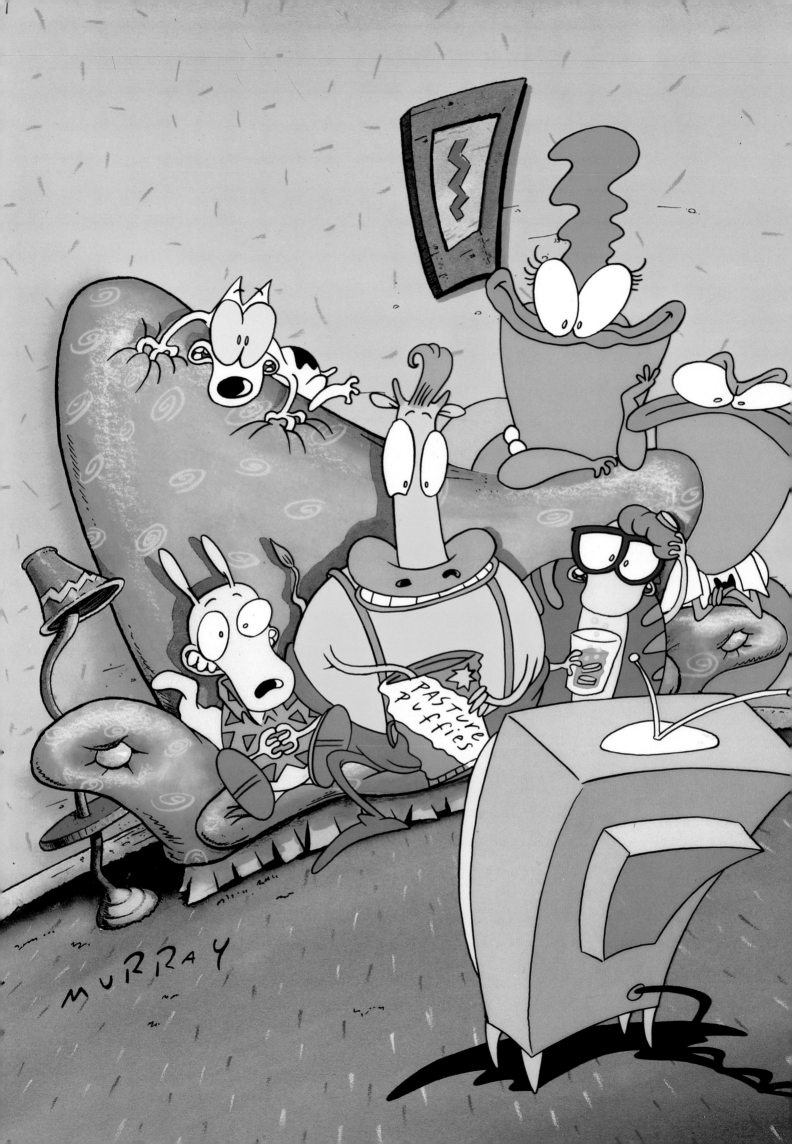

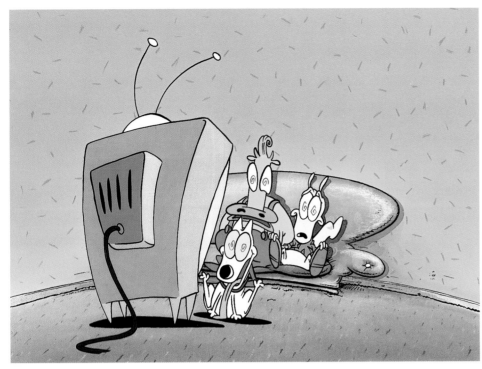

2

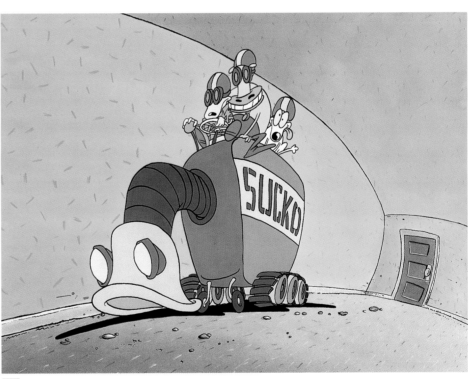

3

1-3
Rocko's Modern Life™,
television series

STUDIO
Games Animation, Inc. © 1994
NICKELODEON (All Rights Reserved)

DESIGNER
Joe Murray

SUPERVISORS/ANIMATORS
Mark O'Hare, Joe Murray

ART DIRECTORS
Steve Hillenburg, Joe Murray, Nick
Jennings

SUPERVISOR/BACKGROUND PAINTER
Nick Jennings

COLOR DESIGNER
Carol Wyatt

Traditional cel animation.

1
Rocko's Modern Life™, television series

STUDIO
Games Animation, Inc. © 1994 NICKELODEON (All Rights Reserved)

SUPERVISOR/ANIMATOR
Chris Savino

ART DIRECTOR
Doug Lawrence

BACKGROUND PAINTER
Adriana Galvez

Traditional cel animation.

2
Milk Mob (Nabisco), television advertisement

STUDIO
Bear Spots Inc.

DESIGNER
Shawn Seles

SUPERVISORS/DIRECTORS
Clive Smith, Joseph Sherman

SUPERVISOR/ANIMATOR
Shawn Seles

ART DIRECTORS
Clive Smith, Joseph Sherman

ADVERTISEMENT AGENCY
Bozell Jacobs Toronto

Live action and table top pixilation composited with cel animation.

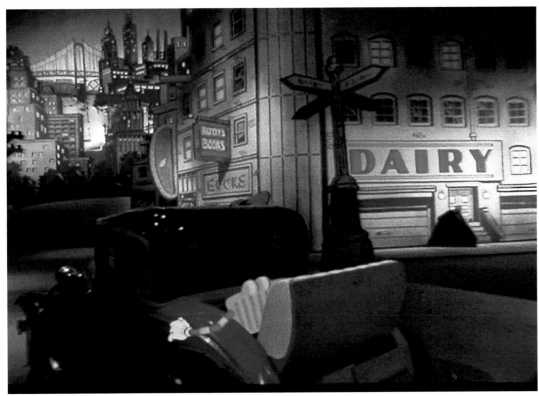

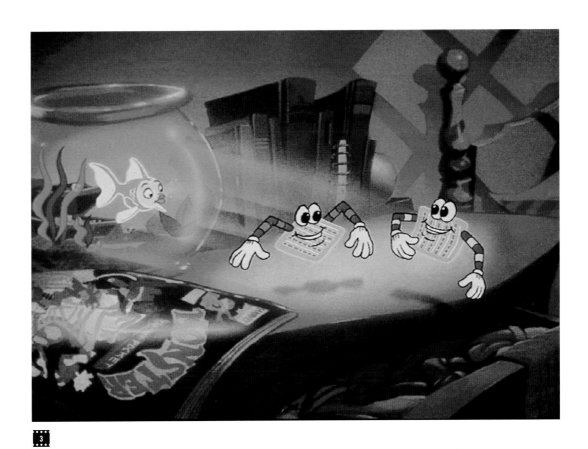

3
**Monsters In My Pocket (Nabisco),
television advertisement**

STUDIO
Bear Spots Inc.

DESIGNER
Shawn Seles

SUPERVISOR/DIRECTOR
Joseph Sherman

SUPERVISOR/ANIMATOR
Shawn Seles

ART DIRECTOR
Joseph Sherman

Traditional cel animation.

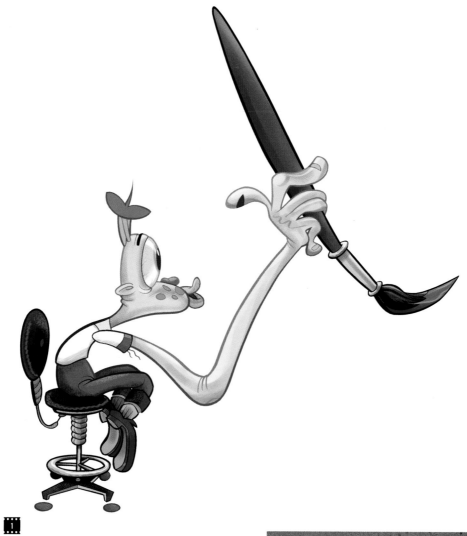

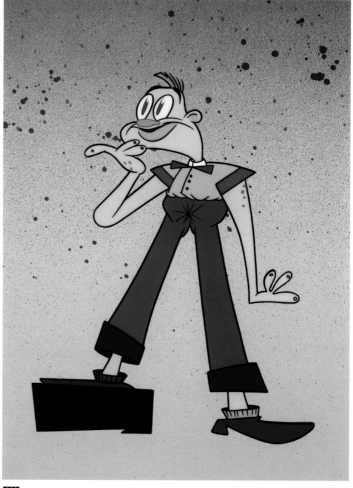

1-2
**Ripping Friends, Jimmy the Hapless
Boy, feature film**
STUDIO
Spumco, Inc.
DESIGNER
John Kricfalusi

*These hand-drawn characters were
embellished with the use of Adobe
Illustrator 5.5, Fractal Design Painter
2.1, and Adobe Photoshop 3.0, as well
cell animation.*

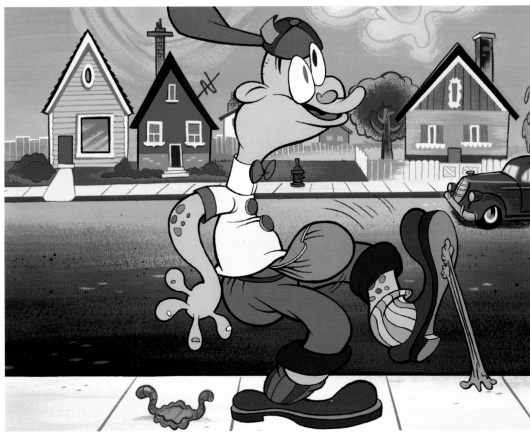

3-4
Jimmy the Idiot Boy, cel painting kit
STUDIO
Spumco, Inc.
DESIGNERS
John Kricfalusi, Craig Kelly
Images created with the use of Adobe Illustrator 5.5, Fractal Design Painter 2.1, and Adobe Photoshop 3.0.

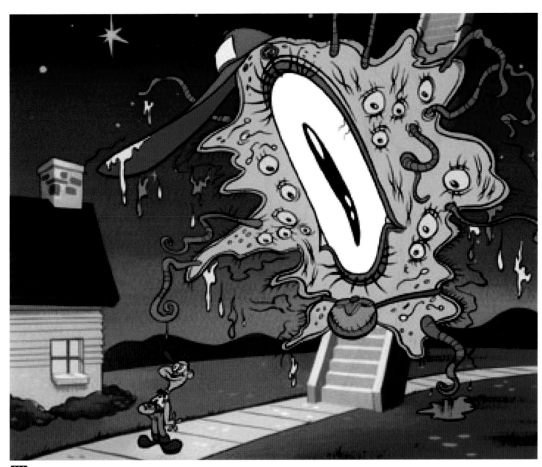

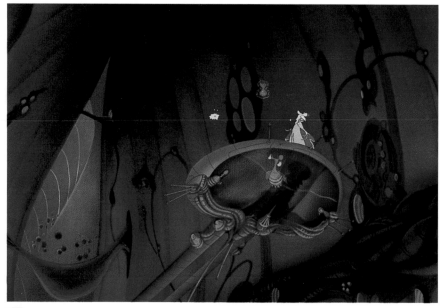

1

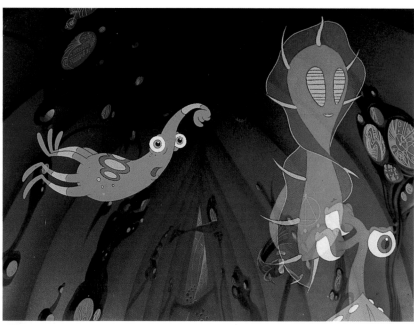

2

1-3
**Journey to the Planets, short film
(theatrical Omnimax presentation)**

STUDIO
Bear Spots Inc.

DESIGNER
Frank Nissen

SUPERVISOR/DIRECTOR
Clive Smith

SUPERVISOR/ANIMATOR
Gary Hurst

ART DIRECTORS
Frank Nissen, Clive Smith

PRODUCERS
**Graeme Ferguson, Toni Myers, Imax
Corporation**

*Cel animation composited with live
action animation.*

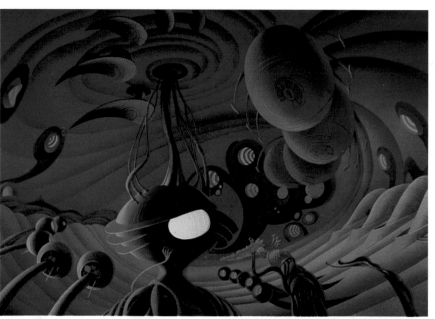

3

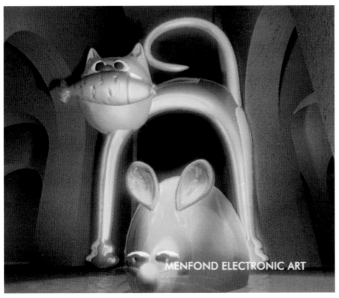

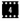

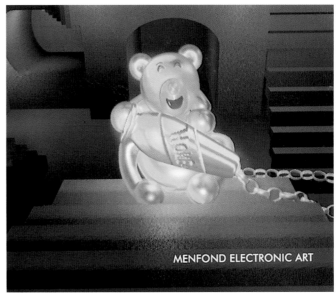

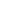

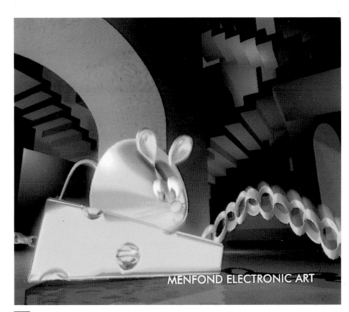

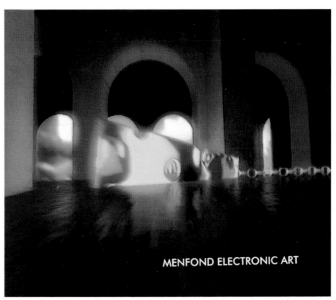

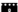

4-8
TST - Golden Match, short film

STUDIO
Menfond Electronic Art & Computer Design Company Limited

PRODUCTION COMPANY
Menfond Electronic Art & Computer Design Company Limited

DESIGNER
Victor Wong

SUPERVISOR/ANIMATOR
Eddy Wong

ART DIRECTOR
Eddy Wong

EXECUTIVE PRODUCER
Thalia Tau

Digital design created with Silicon Graphics Indigo hardware and Alias and Softimage software.

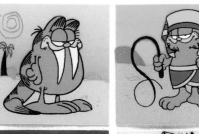

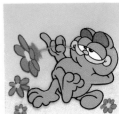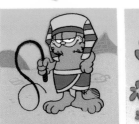

1

**Surprise Party (Garfield Ravioli),
television advertisement**

STUDIO
Bear Spots Inc.

DESIGNER
Shawn Seles

SUPERVISOR/DIRECTOR
Shawn Seles, Clive Smith

SUPERVISOR/ANIMATOR
Shawn Seles

ART DIRECTOR
Shawn Seles

CGI ARTISTS
Fred Luchetti, Peter Hudecki

*Cel animated characters composited
with a three-dimensional computer-
generated environment.*

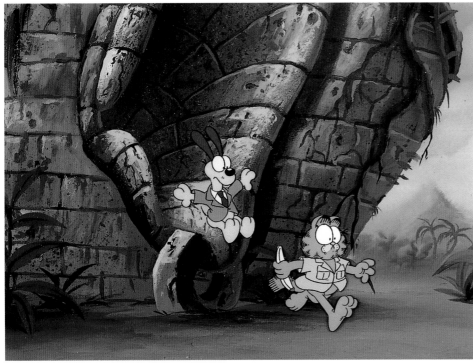

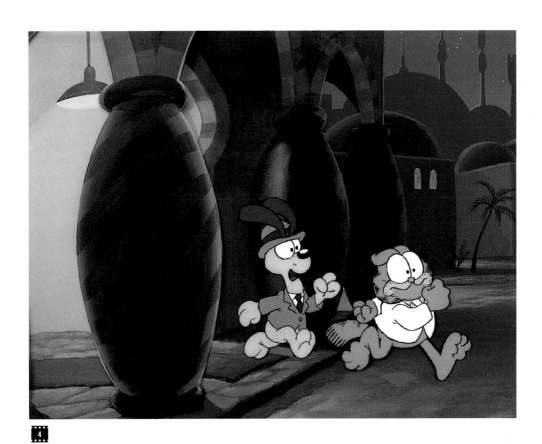

4

2-4
**Garfield: His 9 Lives or Garfield's
Feline Fantasies, television special**

STUDIO
Film Roman

PRODUCTION COMPANY
**Film Roman/Lee Mendelson/United
Media**

DESIGNER
Jim Davis

EXECUTIVE PRODUCER
Phil Roman

Traditional cel animation.

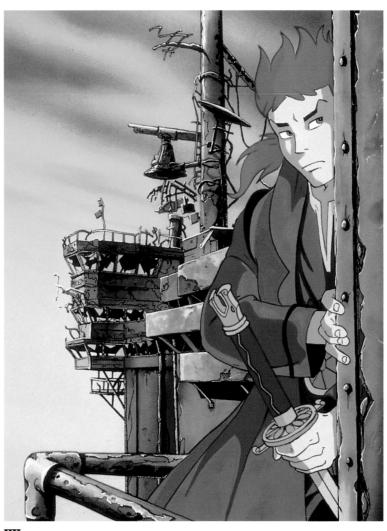

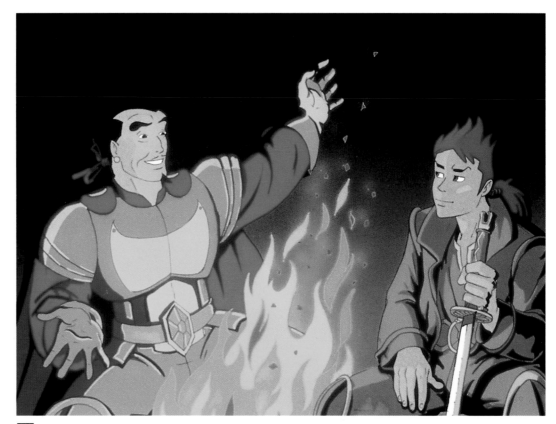

1-4
Highlander, The Animated Series, television series

STUDIO
Gaumont Multimedia

PRODUCER
Marc du Pontarice

Traditional cel animation and digital animation.

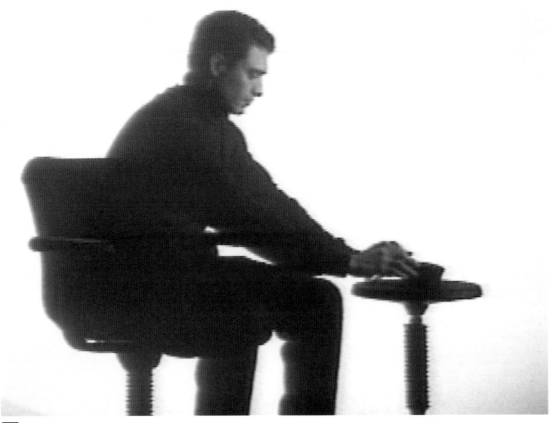

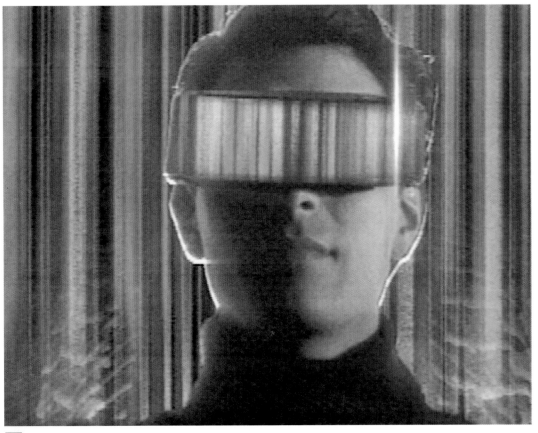

1-4
Virtual Reality, television news promotion
STUDIO
WUSA TV Design Department
PRODUCTION COMPANY
WUSA TV Design Department
DESIGNER
Mary Ruesen Strauss
SUPERVISOR/ANIMATOR
Karen Swenholt
ART DIRECTOR
Mary Ruesen Strauss
PRODUCER
Mag Cumbow
Digital animation created with Microtime DFX DLT.

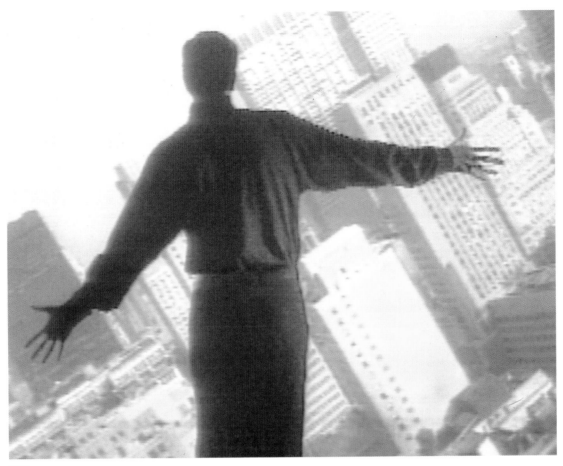

3

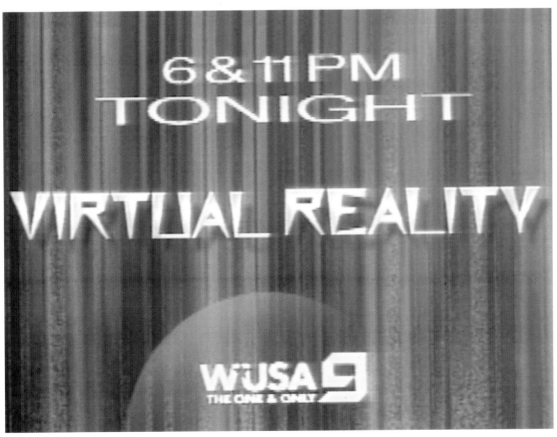

4

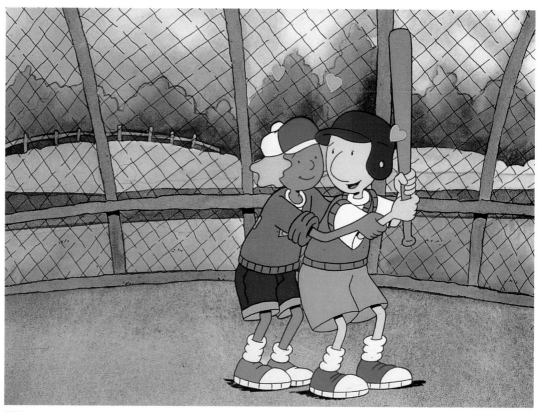

1

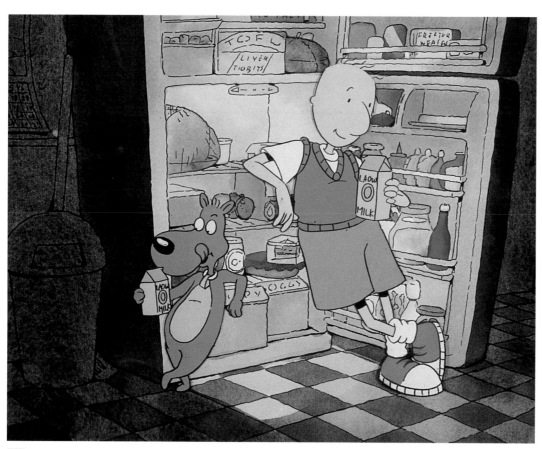

2

1-4
Doug™, television series
STUDIO
**Jumbo Pictures © 1994 NICKELODEON
(All Rights Reserved)**
DESIGNER
Jim Jinkins
Traditional cel animation.

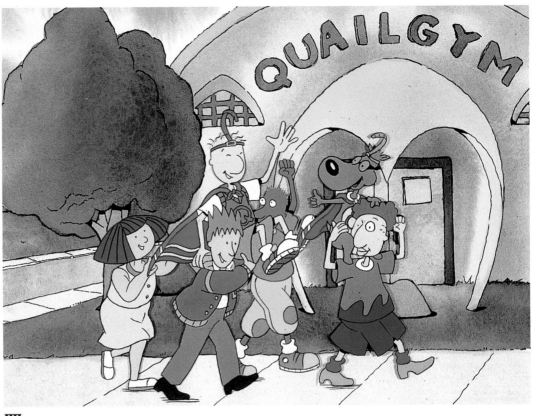

3

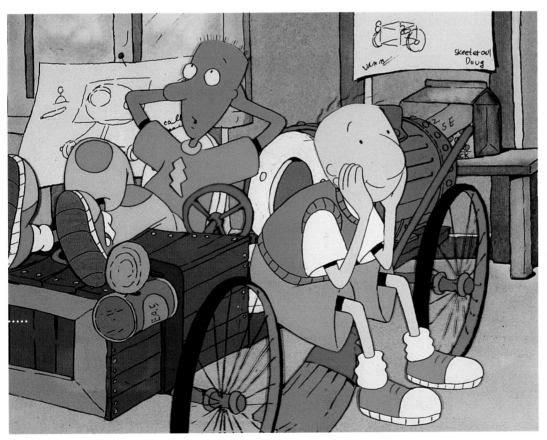

4

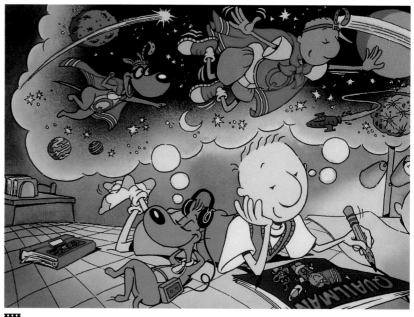

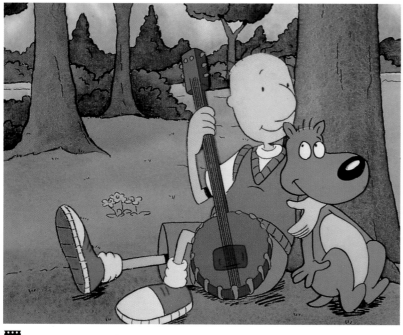

5-7
Doug™, television series

STUDIO
Jumbo Pictures © 1994 NICKELODEON
(All Rights Reserved)
DESIGNER
Jim Jinkins
Traditional cel animation.

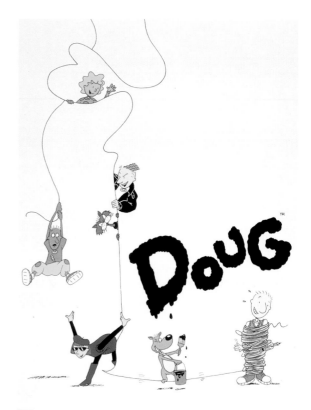

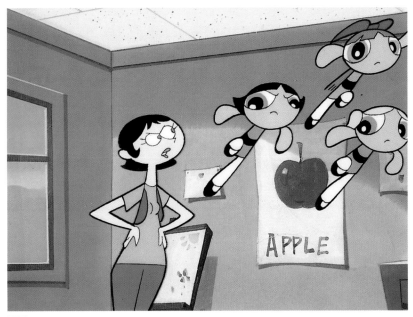

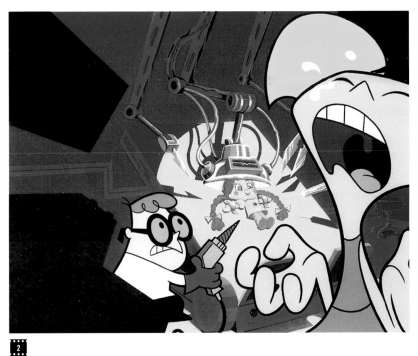

1
The Powerpuff Girls in "Meat Fuzzy Lumkins", short cartoon
STUDIO
© 1995 Hanna-Barbera Cartoons, Inc.
(All Rights Reserved)
DIRECTOR
Genndy Tartakovsky
ART DIRECTOR
Paul Rudish
LAYOUT DESIGNER
Mike Moon
EXECUTIVE PRODUCER
Buzz Potamkin
SUPERVISING PRODUCER
Larry Huber
Traditional cel animation.

2
Dexter's Laboratory "Changes", short cartoon
STUDIO
© 1995 Hanna-Barbera Cartoons, Inc.
(All Rights Reserved)
DIRECTORY
Genndy Tartakovsky
ART DIRECTORS
Craig McCracken, Paul Rudish
EXECUTIVE PRODUCER
Buzz Potamkin
SUPERVISING PRODUCER
Larry Huber
Traditional cel animation.

3
Johnny Bravo, short cartoon
STUDIO
© 1995 Hanna-Barbera Cartoons, Inc.
(All Rights Reserved)
DIRECTOR
Van Partible
BACKGROUND STYLIST
Jane Nussbaum
LAYOUT ARTIST
Virginia Hawes
EXECUTIVE PRODUCER
Buzz Potamkin
SUPERVISING PRODUCER
Larry Huber
Traditional cel animation.

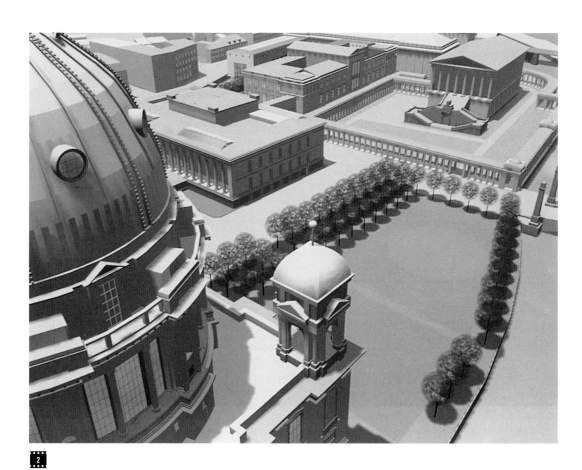

 1

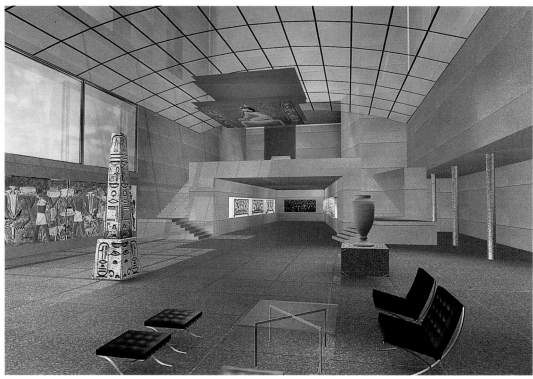

2

1-5
Digital Visions, hyper-realistic architectural renderings

STUDIO
Cat Zentrum

CHARACTER/CREATOR/DESIGNER
Stefan Sonntag

SUPERVISOR/ANIMATOR
Stefan Sonntag

ART DIRECTOR
Järgen Moelle

PRODUCER
Jo Atze

Digital animation completed on a Pentum-90 PC with Autodesk 3-D studio software.

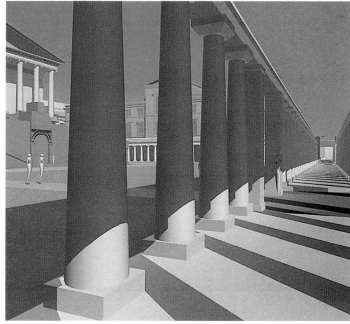

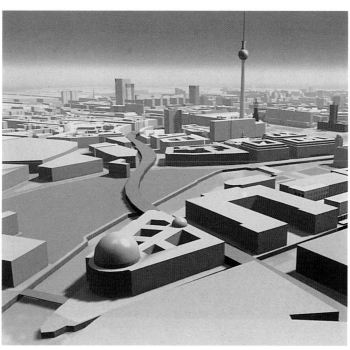

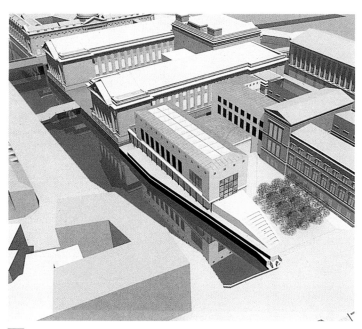

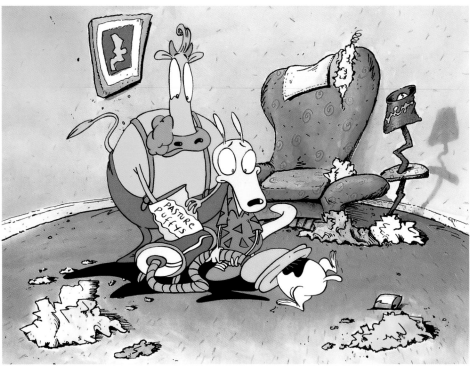

1

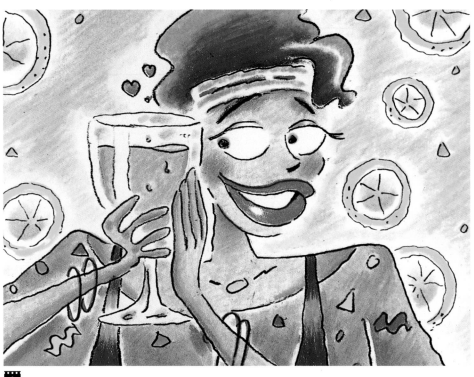

2

1
Rocko's Modern Life™, television series

STUDIO
Games Animation, Inc. ©1994 NICKELODEON (All Rights Reserved)

DESIGNER
Joe Murray

SUPERVISOR/ANIMATOR
Joe Murray

ART DIRECTOR
Joe Murray

SUPERIVSOR/BACKGROUND PAINTER
Nick Jennings

Traditional cel animation.

2
But... (Ocean Spray), television advertisement

STUDIO
Bear Spots Inc.

DESIGNER
Joseph Sherman

ALL DIRECTION
Joseph Sherman

Pencil and crayon rendering and cel animation.

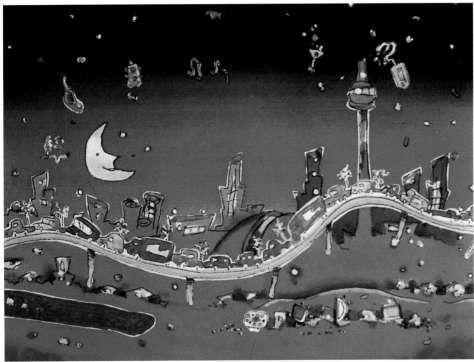

3

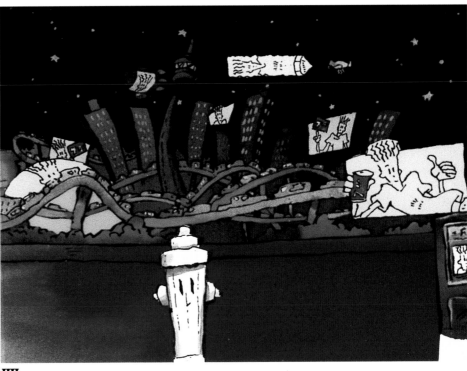

4

3
CBC 740 A.M., television advertisement

STUDIO
Bear Spots Inc.

DESIGNER
Joseph Sherman

SUPERVISOR/DIRECTOR
Paul Teolis

SUPERVISOR/ANIMATOR
Joseph Sherman

ART DIRECTOR
Joseph Sherman

CLIENT
Canadian Broadcasting Corporation

Traditional cel animation.

4
7-UP Fidorrama, television advertisement

STUDIO
Bear Spots Inc.

DESIGNER
Susan Rose

SUPERVISOR/DIRECTOR
Clive Smith/Robin Budd

SUPERVISOR/ANIMATOR
Robin Budd

ART DIRECTOR
Clive Smith/Joseph Sherman

ADVERTISEMENT AGENCY
J. Walter Thompson Toronto

PRODUCER
Leslie Parrot

Live action animation and cel animation.

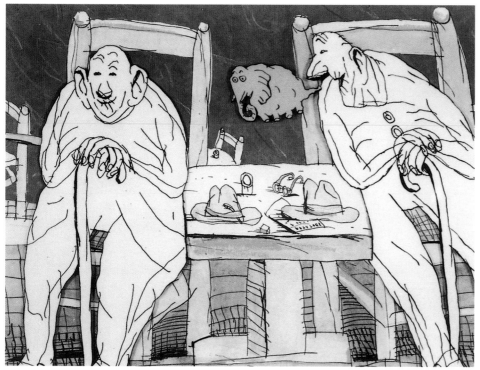

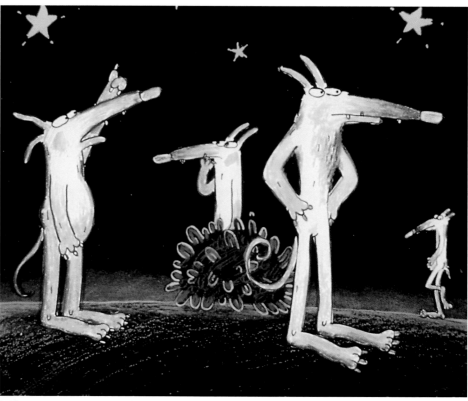

1
Words Words Words, short film
STUDIO
Chechoslovak Film Export
DESIGNER
Michaela Pavlátová
DISTRIBUTOR
Expanded Entertainment
This Academy Award nominee was created with traditional cel animation.

2
Little Wolf, short film
STUDIO
Royal Collage of Art
SUPERVISOR/ANIMATOR
An Vromvaut
DISTRIBUTOR
Expanded Entertainment
Traditional cel animation.

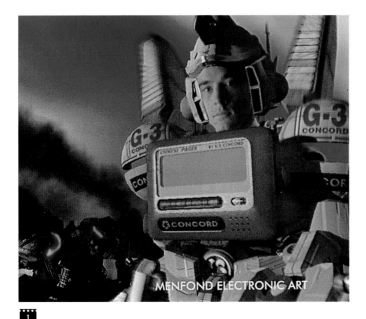

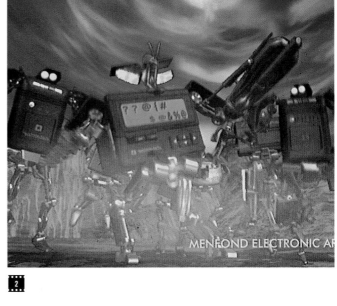

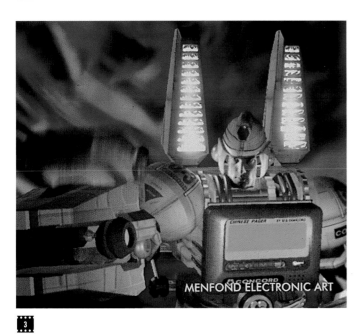

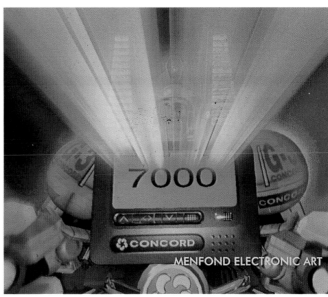

1-5
Concord - G3, television advertisement

STUDIO
Menfond Electronic Art & Computer Design Company Limited

PRODUCTION COMPANY
Menfond Electronic Art & Computer Design Company Limited

DESIGNER
Victor Wong

SUPERVISOR/ANIMATOR
Eddy Wong

ART DIRECTOR
Eddy Wong

EXECUTIVE PRODUCER
Thalia Tau

Digital design created with Silicon Graphics Indigo hardware and Alias and Softimage software.

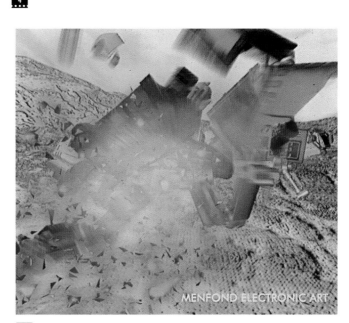

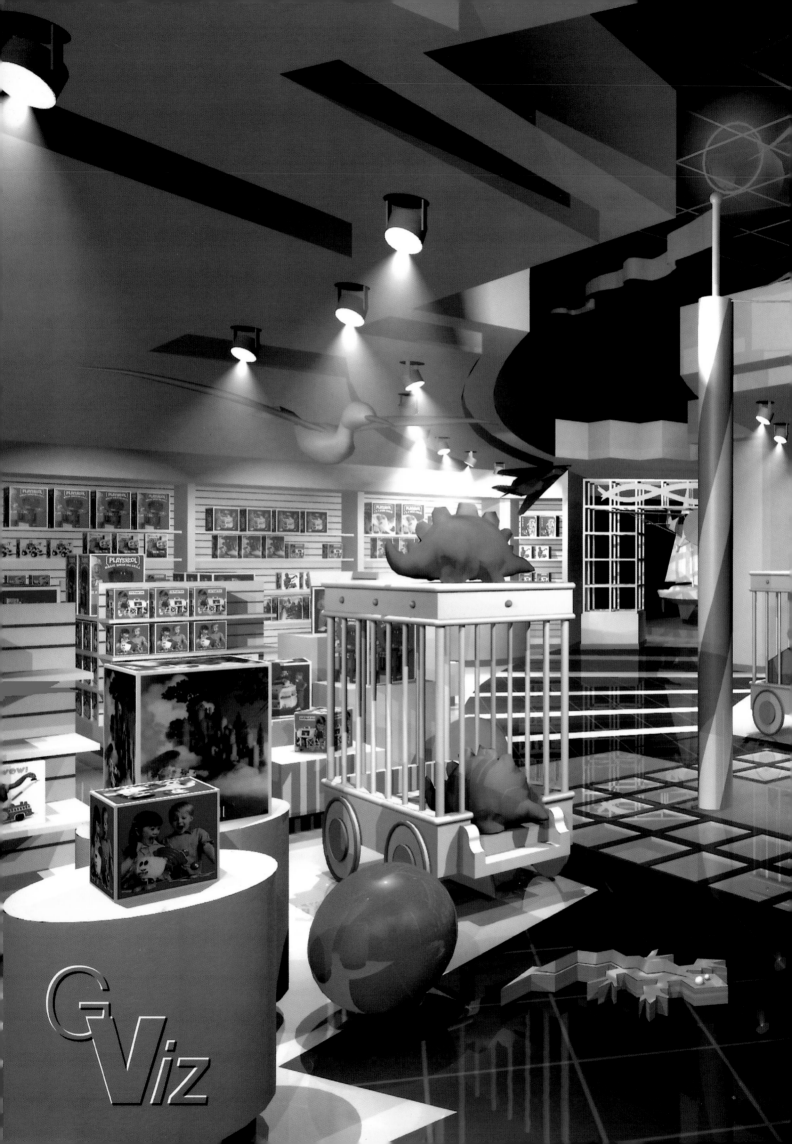

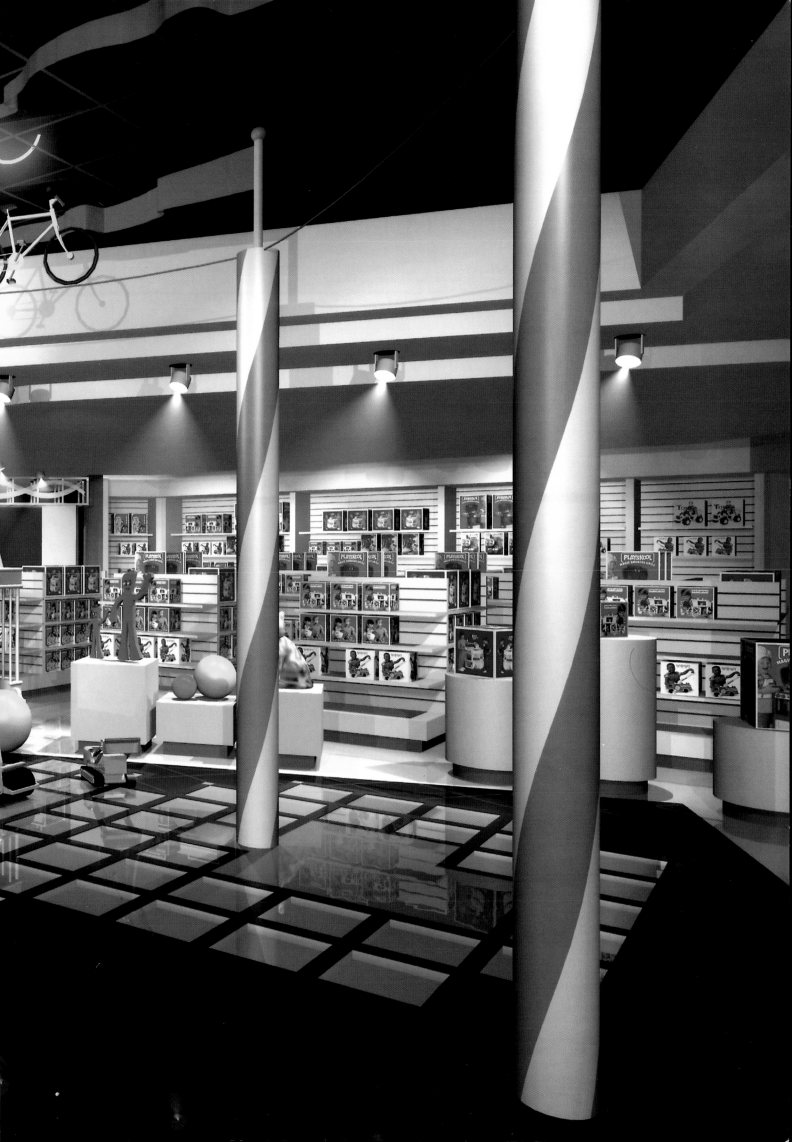

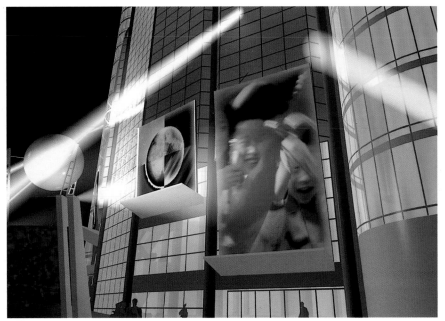

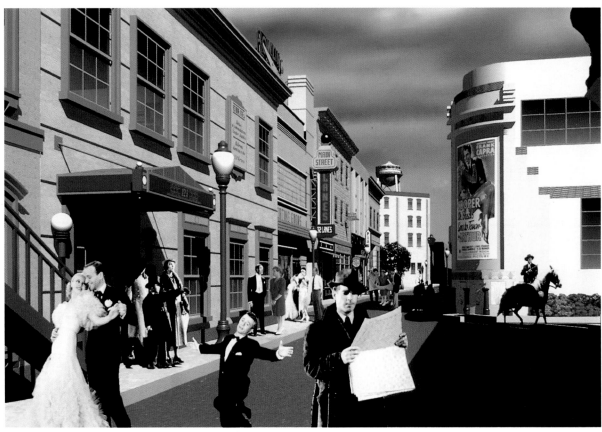

(Previous spread)
**Toy Store Design, architectural
hyper-realistic rendering**

STUDIO
Gensler & Associates

PRODUCTION COMPANY
Gensler & Associates

SUPERVISOR/ANIMATOR
Eric Hanson

ART DIRECTOR
Eric Hanson

*Digital animation created with Alias
Power Animator on Silicon Graphics
hardware.*

1
**Themed Retail Design, architectural
hyper-realistic rendering**

STUDIO
Gensler & Associates

PRODUCTION COMPANY
Gensler & Associates

SUPERVISOR/ANIMATOR
Eric Hanson

ART DIRECTOR
Eric Hanson

*Digital animation created with Alias
Power Animator on Silicon Graphics
hardware.*

2
**Sony Pictures studio, architectural
hyper-realistic rendering**

STUDIO
Gensler & Associates

PRODUCTION COMPANY
Gensler & Associates

SUPERVISOR/ANIMATOR
Eric Hanson

ART DIRECTOR
Eric Hanson

*Digital animation created with Alias
Power Animator on Silicon Graphics
hardware.*

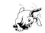

3-4
The Operation, television series illustration

STUDIO
Take One Productions
SUPERVISOR/ANIMATOR
Paul Graham
ART DIRECTOR
Paul Graham
CLIENT
Advanced Medical Education

Digital animation created on Softimage Creative Environment software.

1
Marine Grafics, logo treatment
STUDIO
Take One Productions
SUPERVISOR/ANIMATOR
Paul Graham
ART DIRECTOR
Paul Graham
CLIENT
Marine Grafics
*Digital animation created on Softimage
Creative Environment software.*

2
Untitled, self-promotion
STUDIO
Take One Productions
SUPERVISOR/ANIMATOR
Paul Graham
ART DIRECTOR
Paul Graham
*Digital animation created on Softimage
Creative Environment software.*

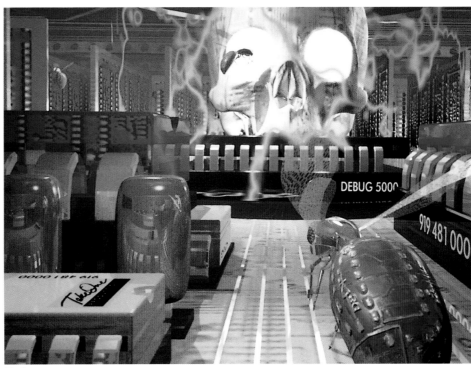

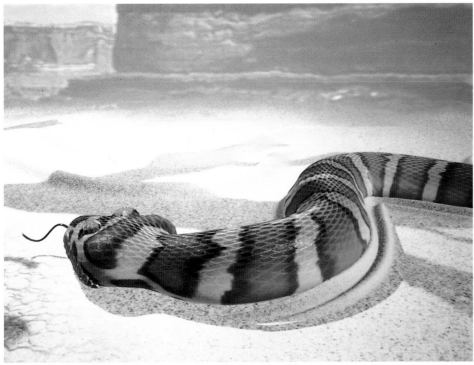

3
Computer Bug, promotion
STUDIO
Take One Productions
SUPERVISOR/ANIMATOR
Paul Graham
ART DIRECTOR
Paul Graham
Digital animation created on Softimage Creative Environment software.

4
Desert Snake, promotion
STUDIO
Take One Productions
SUPERVISOR/ANIMATOR
Paul Graham
Digital animation created on Softimage Creative Environment software.

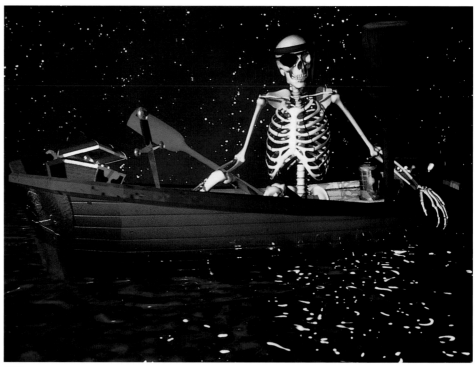

1

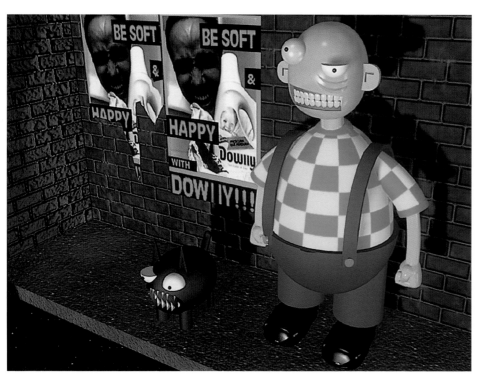

 2

1
Very Old Pirate, promotion

STUDIO
Take One Productions

SUPERVISOR/ANIMATOR
Paul Graham

ART DIRECTOR
Paul Graham

Digital animation created on Softimage
Creative Environment software.

2
Better Be Soft, short film

STUDIO
ISC Lab-Pratt Institute

DESIGNER
Felipe Lara

SUPERVISOR/ANIMATOR
Felipe Lara

Digital animation completed with
Autodesk 3-D studio software on an IBM
486 DX.

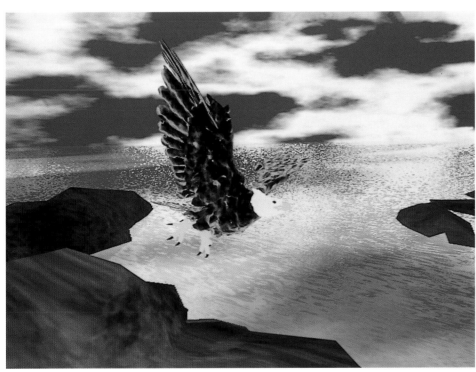

3-4
Lost Island, academic project

STUDIO
**University of Zurich, Institute
of Informatics**

PRODUCTION COMPANY
Multimedia Laboratory

DESIGNERS
Urs Flueck, Michael Beck

SUPERVISORS/ANIMATORS
Urs Flueck, Michael Beck

ART DIRECTORS
Urs Flueck, Michael Beck

ACADEMIC SUPERVISORS
**Professor Peter Stucki,
Thomas Fromherz**

*TDI 3.0 software and an IBM RS/6000
were used to create this project.*

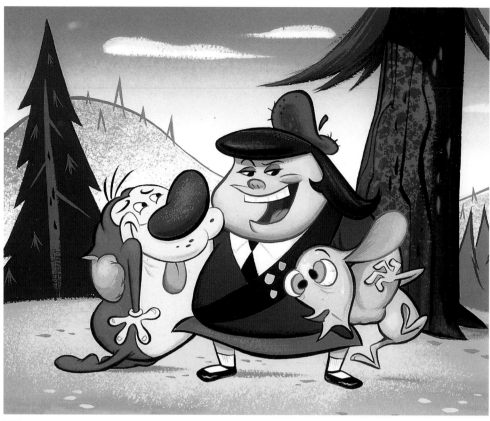

1

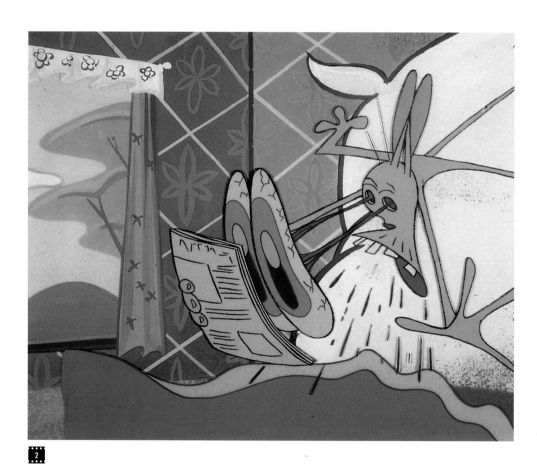

2

1-5
The Ren and Stimpy Show©,
television series

STUDIO
Games Production © 1994
NICKELODEON (All Rights Reserved)
DESIGNER
John Kricfalusi
SUPERVISOR/DIRECTOR
Bob Camp
Traditional cel animation.

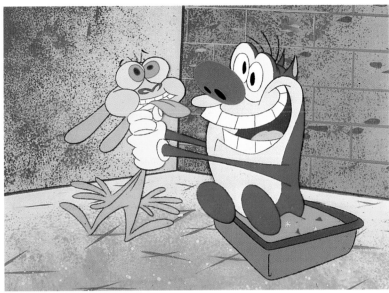

3

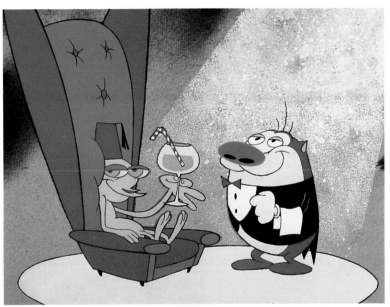

4

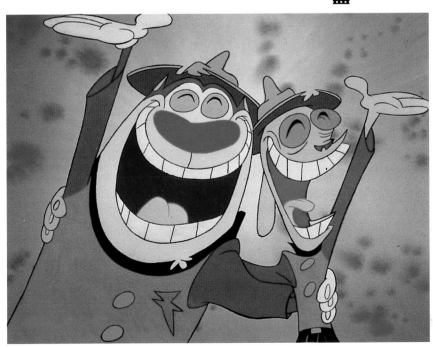

5

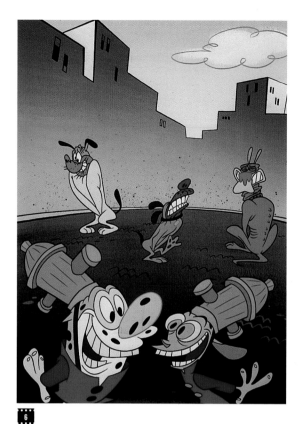

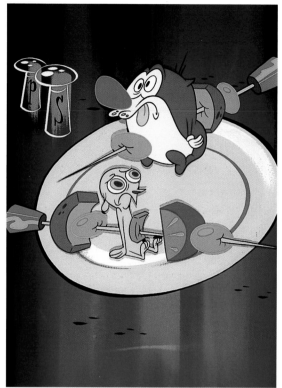

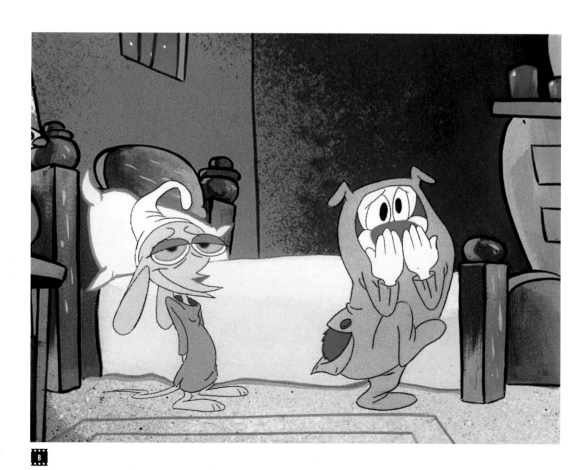

6-10
The Ren and Stimpy Show
television series

STUDIO
Games Production © 1994
NICKELODEON (All Rights Reserved)

DESIGNER
John Kricfalusi

SUPERVISOR/DIRECTOR
Bob Camp

Traditional cel animation.

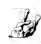

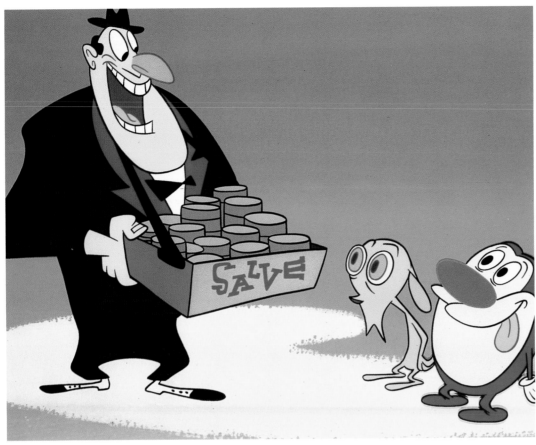

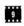

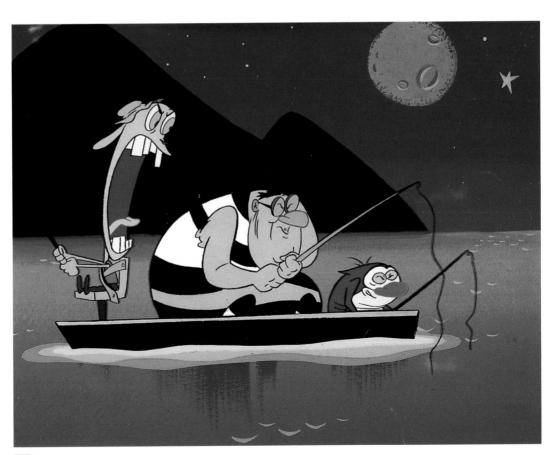

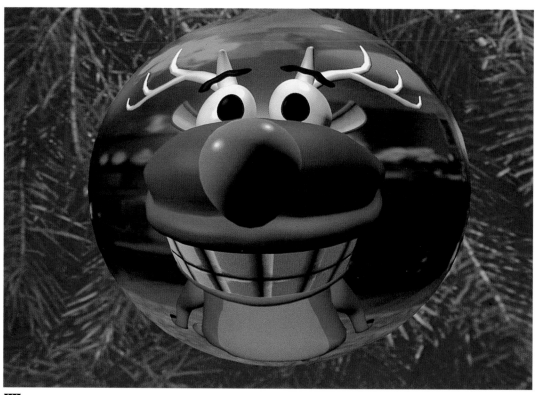

1

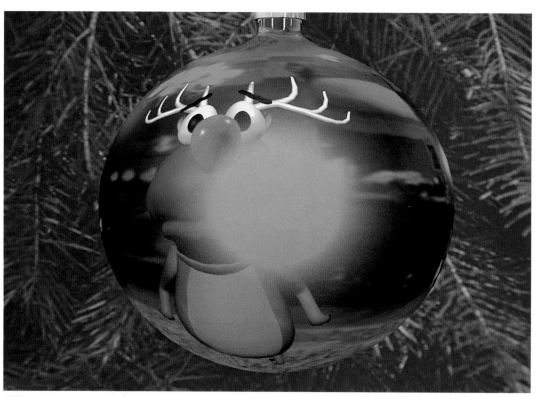

2

1-4
Seasons Greetings from KET, television network promotion

PRODUCTION COMPANY
Kentucky Educational Television

DESIGNER
Beau Janzen

SUPERVISOR/ANIMATOR
Beau Janzen

DIRECTOR
Krista Seymour

AUDIO/MUSIC DESIGN
Chuck Burgess

Digital animation created with Wavefront Advanced Visualizer software on a Silicon Graphics Indigo workstation.

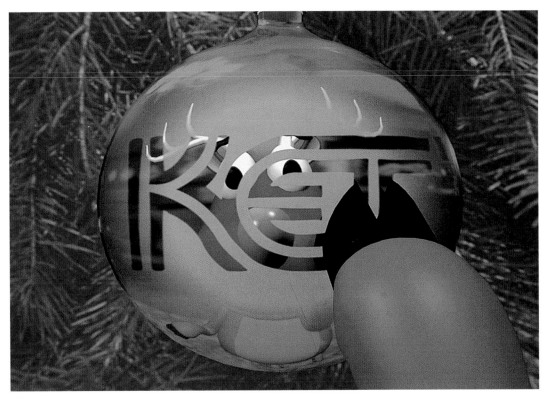

3

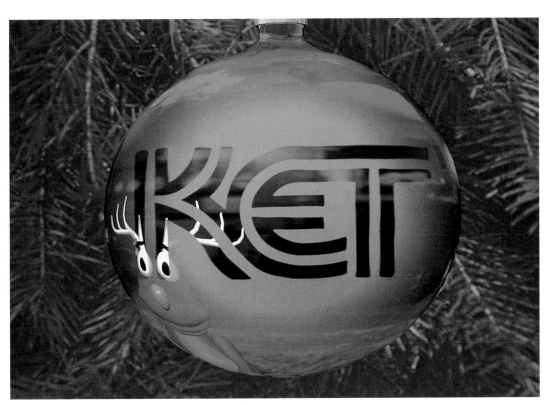

4

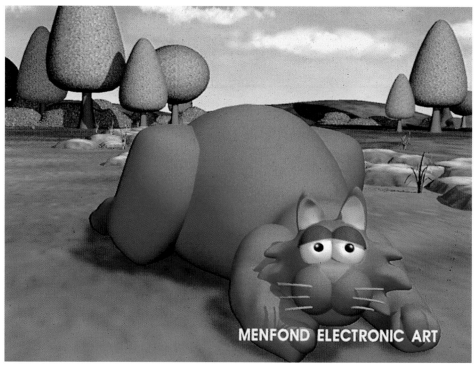

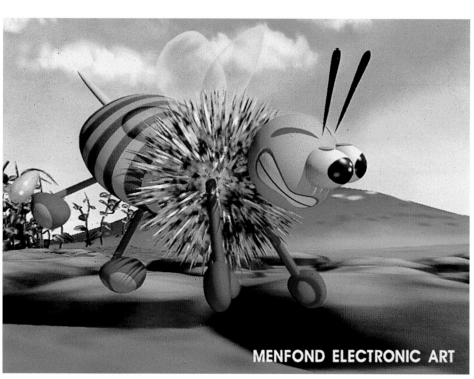

1-4
**Vita Chrysanthemun Tea - Honey Bee,
television advertisement**

STUDIO
**Menfond Electronic Art & Computer
Design Company Limited**

PRODUCTION COMPANY
**Menfond Electronic Art & Computer
Design Company Limited**

DESIGNER
Victor Wong

SUPERVISOR/ANIMATOR
Eddy Wong

ART DIRECTOR
Eddy Wong

EXECUTIVE PRODUCER
Thalia Tau

*Digital design created with Silicon
Graphics Indigo hardware and Alias and
Softimage software.*

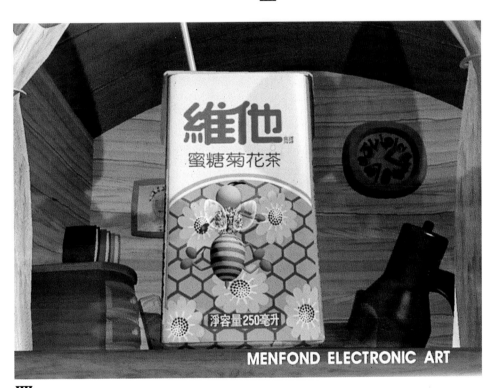

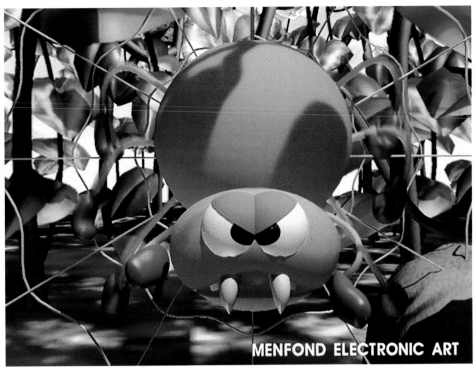

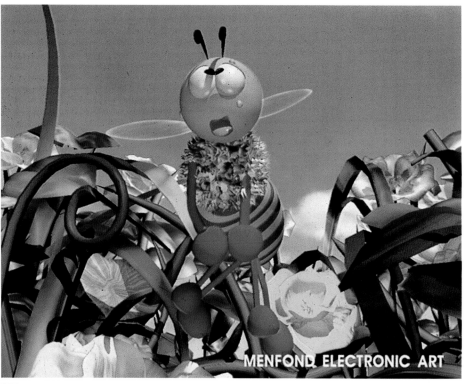

5

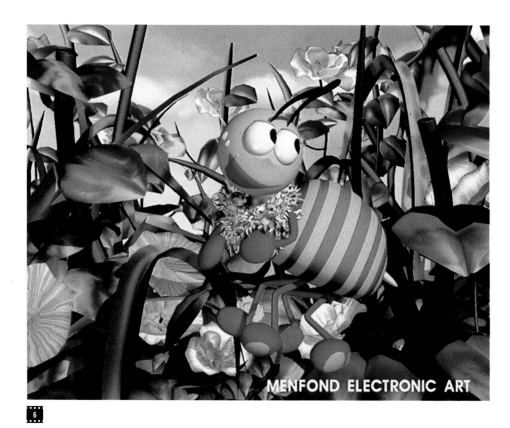

6

5-6
**Vita Chrysanthemun Tea - Honey Bee,
television advertisement**

STUDIO
**Menfond Electronic Art & Computer
Design Company Limited**

PRODUCTION COMPANY
**Menfond Electronic Art & Computer
Design Company Limited**

DESIGNER
Victor Wong

SUPERVISOR/ANIMATOR
Eddy Wong

ART DIRECTOR
Eddy Wong

EXECUTIVE PRODUCER
Thalia Tau

*Digital design created with Silicon
Graphics Indigo hardware and Alias and
Softimage software.*

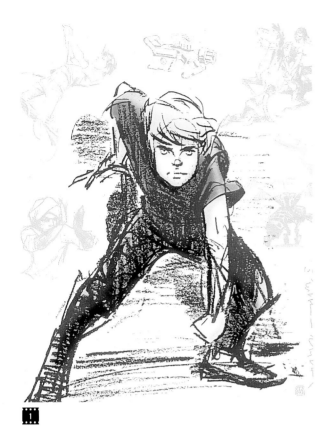

1

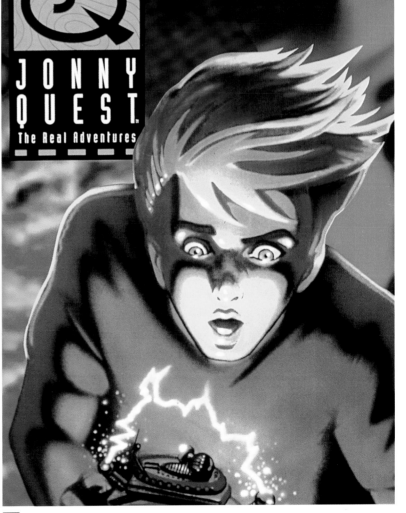

1-2
**The Real Adventures of Jonny Quest,
television series**
STUDIO
© 1995 Hanna-Barbera Cartoons, Inc.
(All Rights Reserved)
PRODUCERS
Takashi, Peter Lawrence
DIRECTORS
Takashi, Peter Lawrence
Traditional cel animation.

2

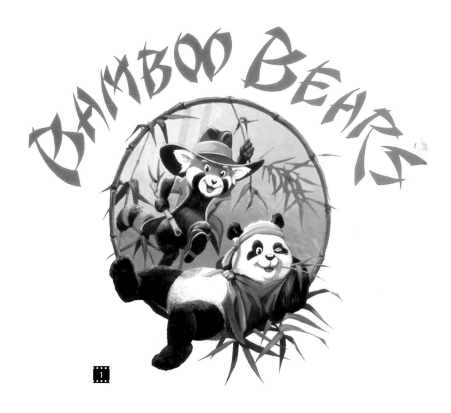

MARINA PRODUCTIONS
Presents

1-2
**Bamboo Bears, Mr. Men,
television series**
STUDIO
Marina Productions
Traditional cel animation.

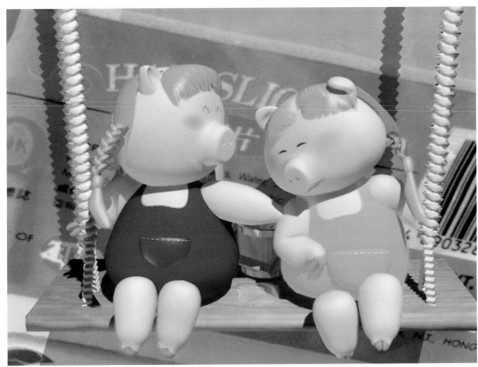

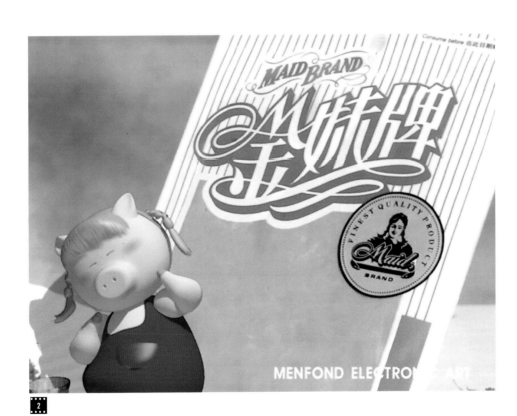

1-2
Maid Ham - Mona & Lisa, television advertisement

STUDIO
Menfond Electronic Art & Computer Design Company Limited

PRODUCTION COMPANY
Menfond Electronic Art & Computer Design Company Limited

DESIGNER
Victor Wong

SUPERVISOR/ANIMATOR
Eddy Wong

ART DIRECTOR
Eddy Wong

EXECUTIVE PRODUCER
Thalia Tau

There are two Pigs - Mona and Lisa both would like to be Miss Maid Ham.

Digital design created with Silicon Graphics Indigo hardware and Alias and Softimage software.

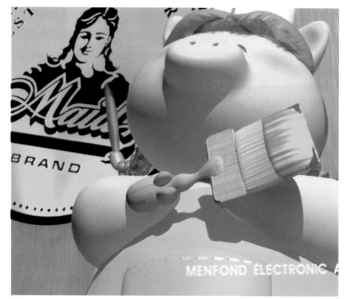

3

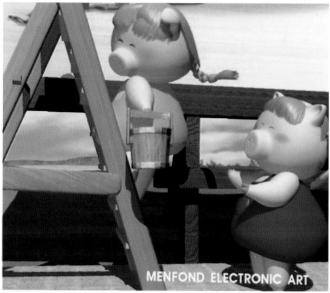

4

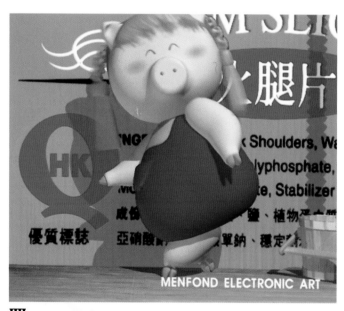

5

6

3-7
Maid Ham - Mona & Lisa, television advertisement

STUDIO
Menfond Electronic Art & Computer Design Company Limited

PRODUCTION COMPANY
Menfond Electronic Art & Computer Design Company Limited

DESIGNER
Victor Wong

SUPERVISOR/ANIMATOR
Eddy Wong

ART DIRECTOR
Eddy Wong

EXECUTIVE PRODUCER
Thalia Tau

There are two Pigs - Mona and Lisa both would like to be Miss Maid Ham.

Digital design created with Silicon Graphics Indigo hardware and Alias and Softimage software.

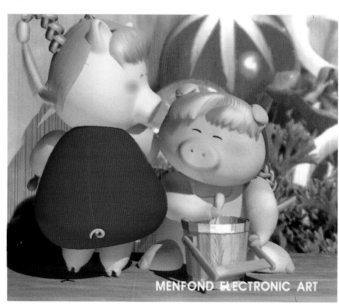

7

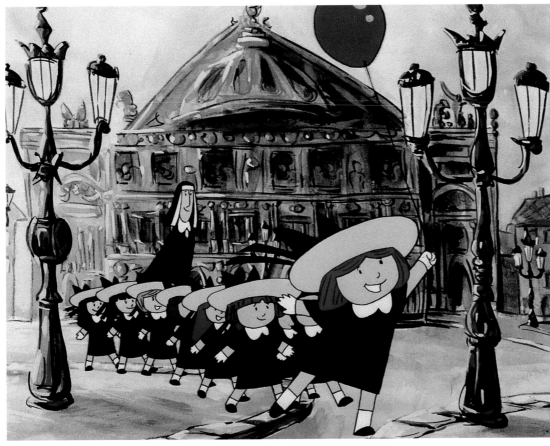

1-2
Madeline, short film
STUDIO
DIC Entertainment
DESIGNER
DIC Entertainment
SUPERVISOR/DIRECTOR
Stan Phillips
SUPERVISOR
Sean Platter
Traditional cel animation.

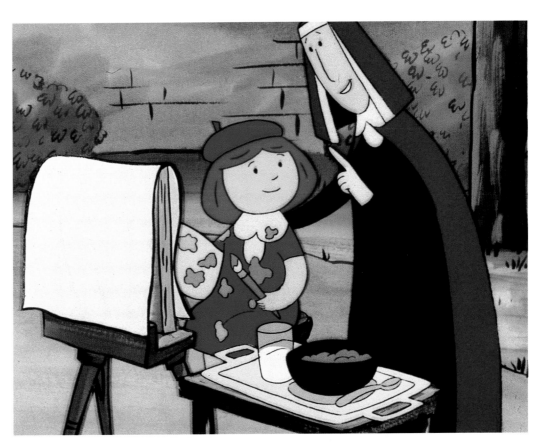

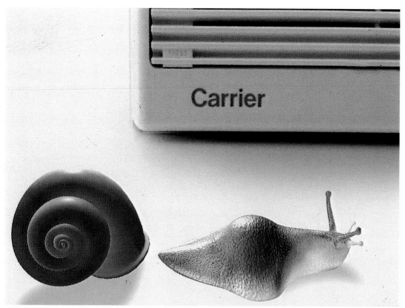

1

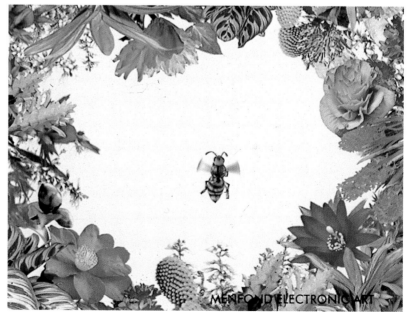

2

1-3
Carrier - Snail, Bee, Owl, television advertisement

STUDIO
Menfond Electronic Art & Computer Design Company Limited

PRODUCTION STUDIO
Menfond Electronic Art & Computer Design Company Limited

DESIGNER
Victor Wong

SUPERVISOR/ANIMATOR
Eddy Wong

ART DIRECTOR
Eddy Wong

EXECUTIVE PRODUCER
Thalia Tau

Digital design created with Silicon Graphics Indigo hardware and Alias and Softimage software.

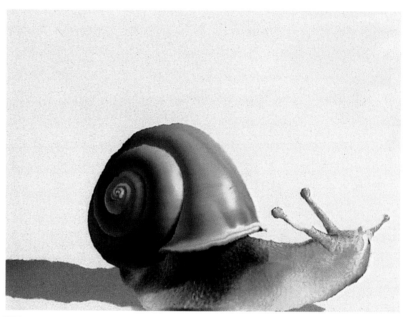

3

4

5

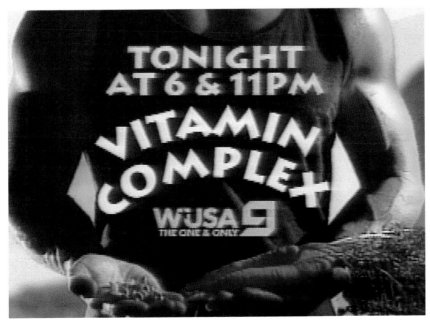

6

4-6
Vitamin Complex, television series promotion

STUDIO
WUSA TV Design Department

PRODUCTION COMPANY
WUSA TV Design Department

DESIGNER
Mary Ruesen Strauss

SUPERVISOR/ANIMATOR
Karen Swenholt

ART DIRECTOR
Mary Ruesen Strauss

PRODUCER
Paige Canaday

Digital animation created with Microtime DFX DLT.

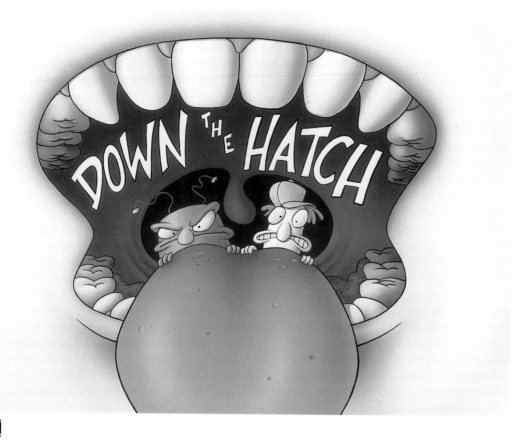

1

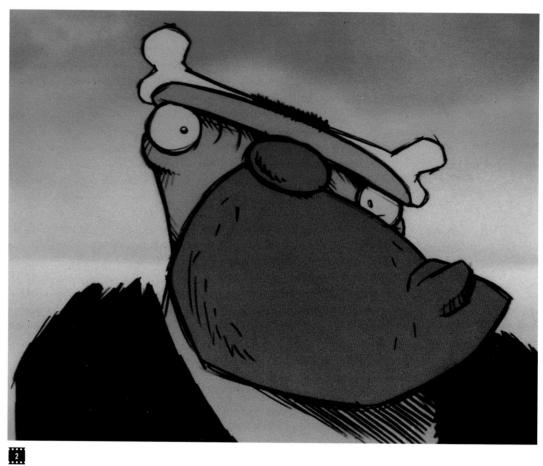

1
Rocko's Modern Life™, television series
STUDIO
**Games Animation, Inc. ©1994
NICKELODEON (All Rights Reserved)**
DESIGNER
Joe Murray
SUPERVISOR/ANIMATOR
Chris Savino
ART DIRECTOR
Doug Lawrence
SUPERVISOR/BACKGROUND PAINTER
Nick Jennings
Traditional cel animation.

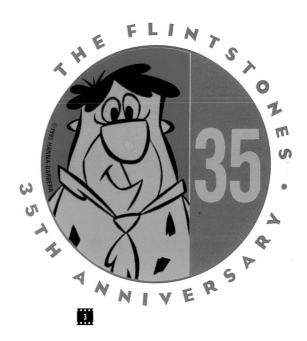

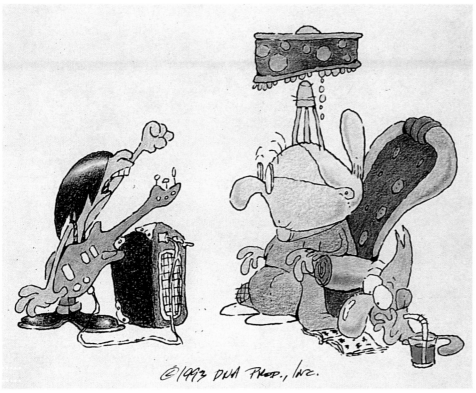

2
Pre-Hysterical Daze, short film
STUDIO
Gavrilo Gnatovich
DESIGNER
Gavrilo Gnatovich
DISTRIBUTOR
Expanded Entertainment
Traditional cel animation.

3
The Flintstones 35th Anniversary, multimedia event logo
STUDIO
© 1995 Hanna-Barbera Cartoons, Inc. (All Rights Reserved)
CREATOR
Craig Kellman
ART DIRECTOR
Russell Hicks
DESIGNER
Paris Caine
Traditional cel animation.

4
Nanna and Lil Puss Puss Show, short film
STUDIO
DNA
DIRECTORS
Keith Alcorn, John Daves
DESIGNERS
Keith Alcorn, John Daves
DISTRIBUTOR
Expanded Entertainment
Traditional cel animation.

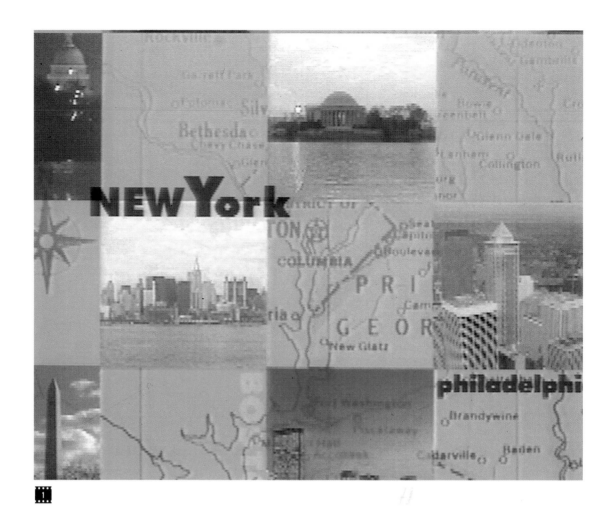

1

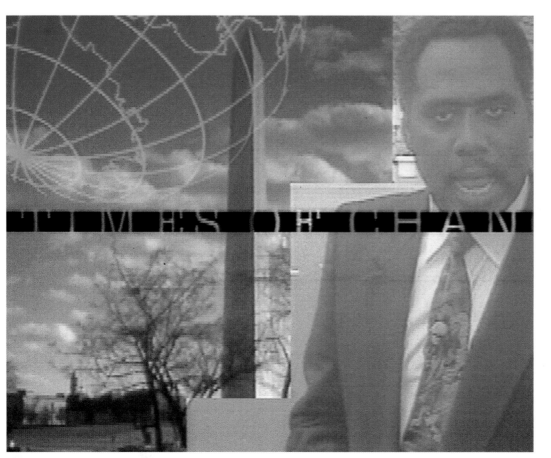

2

1-4
Image Campaign, television station promotion

STUDIO
WUSA TV Design Department

PRODUCTION COMPANY
WUSA TV Design Department

DESIGNER
Mary Ruesen Strauss

SUPERVISOR/ANIMATOR
Donna Beard

ART DIRECTOR
Mary Ruesen Strauss

PRODUCER
Dawn Rodney

Digital animation created with Microtime DFX DLT.

3

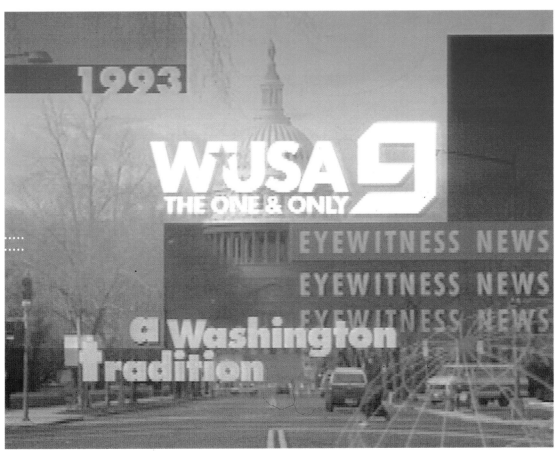

4

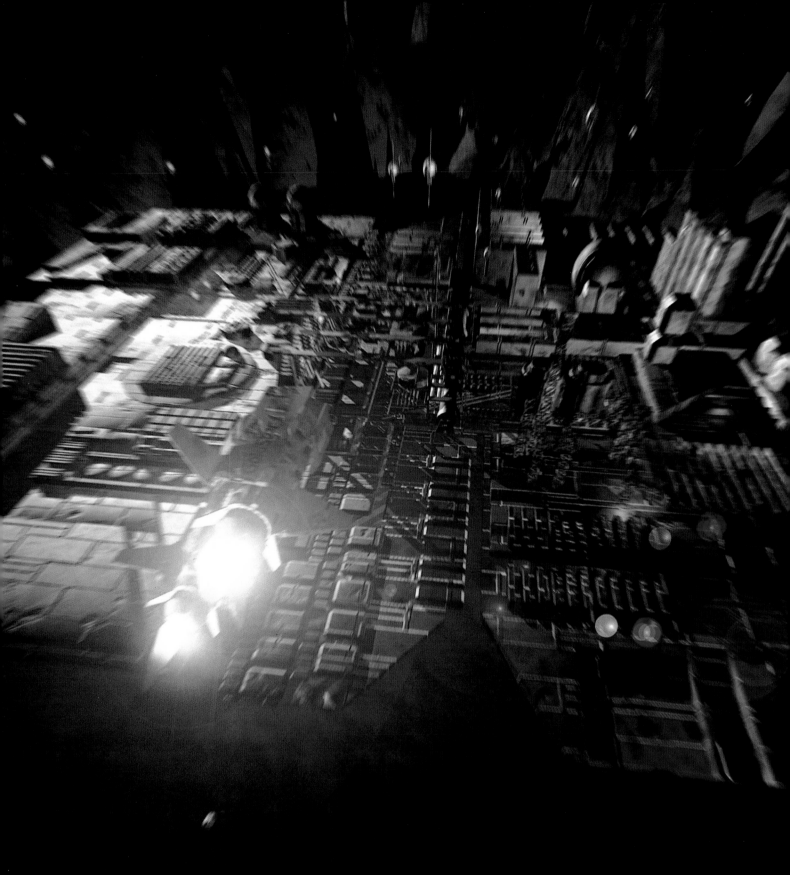

Ajax

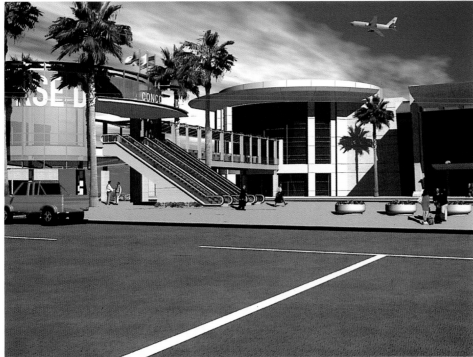

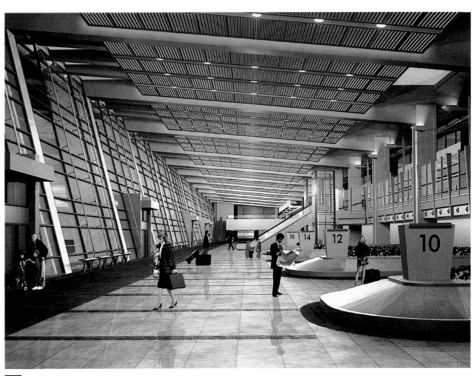

1
Ajax, short film
PRODUCTION COMPANY
Semicolon II Grafix
DESIGNER
Sungho Jang
SUPERVISOR/ANIMATOR
Changjin Im
ART DIRECTOR
Changjin Im

An Iris Crimson computer and Wavefront software were used for this animation.

2–3
San Diego Airport Design, architectural hyper-realistic rendering
STUDIO
Gensler & Associates
PRODUCTION COMPANY
Gensler & Associates
SUPERVISOR/ANIMATOR
Eric Hanson
ART DIRECTOR
Eric Hanson

Digital animation created with Alias Power Animator on Silicon Graphics hardware.

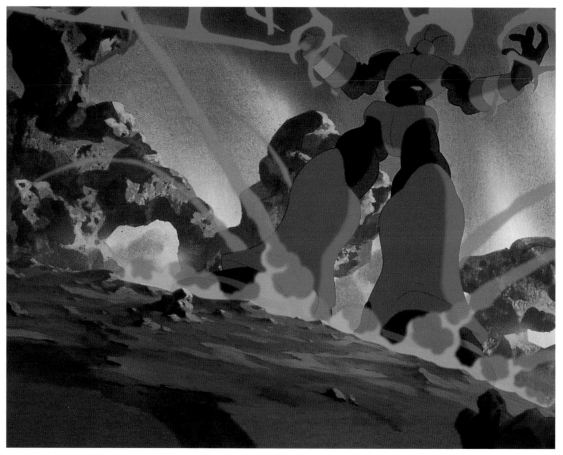

1-4
Prelude to Eden, short film
STUDIO
Michel Gagne
CHARACTER CREATOR/DESIGNER
Michel Gagne
SUPERVISOR/ANIMATOR
Michel Gagne
ART DIRECTOR
Barry Atkinson

Film was animated on paper and the backgrounds painted on illustration boards. A 90 mhz Pentium computer and ANIMO and TIFFANY software were used to turned scanned artwork into digital animation.

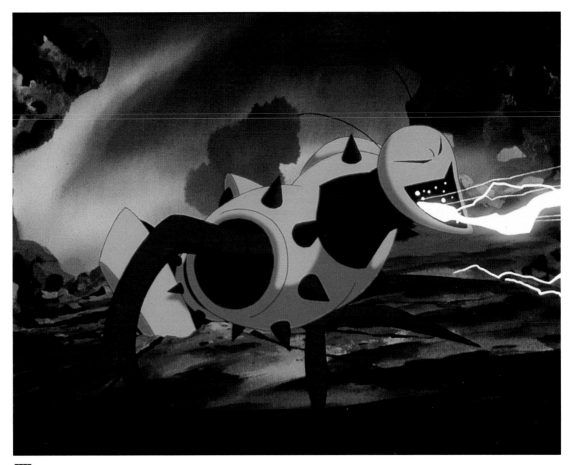

3

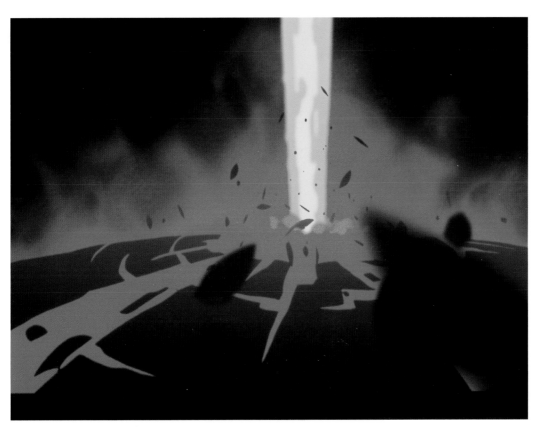

4

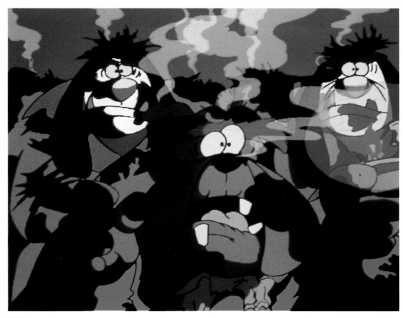

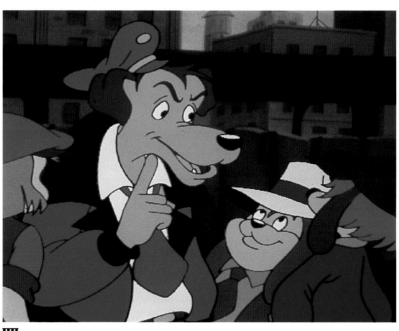

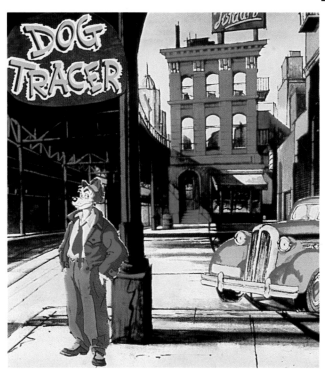

1-3
Dog Tracer,
television series
STUDIO
Marina Productions
Traditional cel animation.

4-5
Opening (Robocop Commander Cash),
animated inserts for live action
television series
STUDIO
Bear Spots Inc. © 1994 Robocop
Productions Limited Partnership,
courtesy of Skyvision Entertainment
DESIGNER
Ken Morresey, Joe Pearson
SUPERVISOR/DIRECTOR
Ken Morresey
SUPERVISOR/ANIMATOR
Ken Morresey
ART DIRECTOR
Ken Morresey, Joe Pearson
Traditional cel animation.

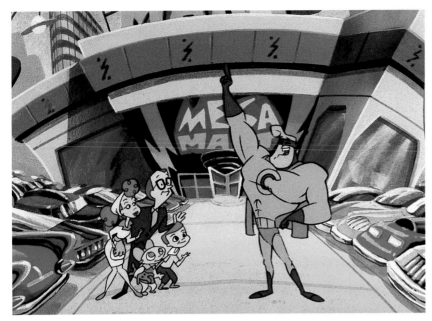

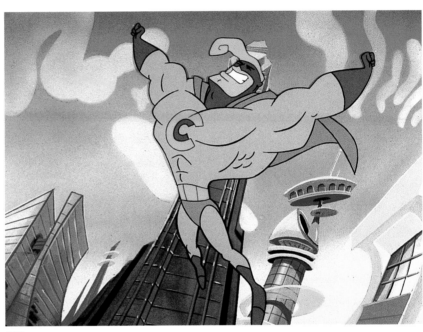

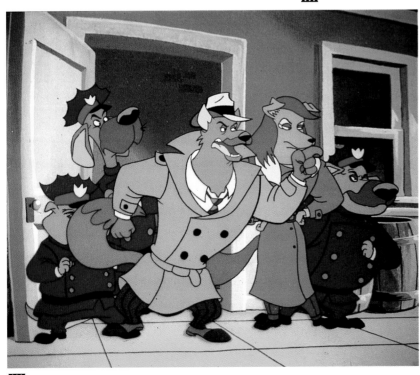

6
Dog City III, animated television series

STUDIO
Nelvana Limited
© 1994 Nelvana Limited
(All Rights Reserved)

DESIGNER
**Jim Henson Productions, Inc.,
Dog City characters**
™ & © Jim Henson Productions, Inc.

SUPERVISORS/DIRECTORS
John Van Bruggen/Dave Pemberton

SUPERVISOR/ANIMATOR
Brad Goodchild

LINE PRODUCER
Marianne Culbert

Cel animation and puppet animation.

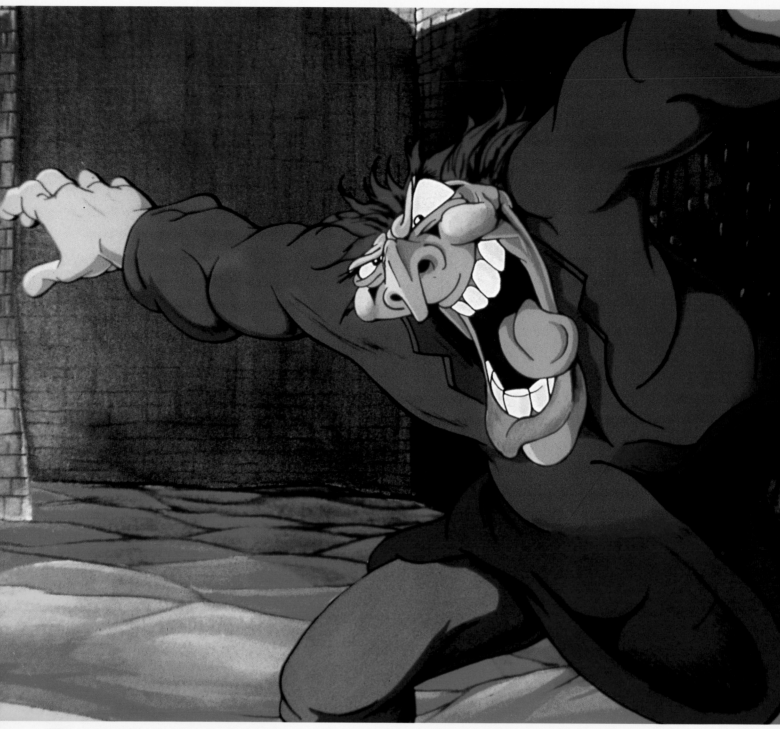

1
Lazar, short film
STUDIO
Gavrilo Gnatovich
DISTRIBUTOR
Expanded Entertainment
Traditional cel animation.

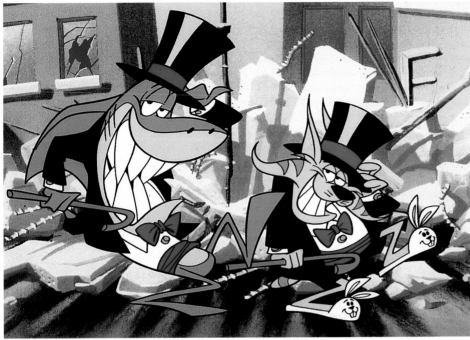

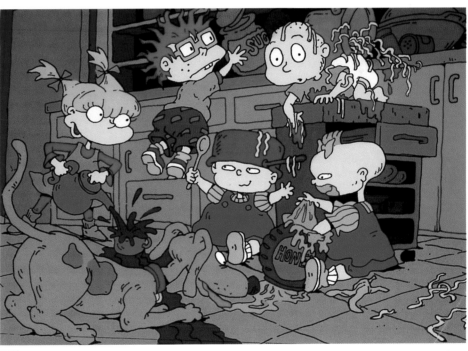

2
Pfish & Chip in "Short Pfuse",
short cartoon
STUDIO
© 1995 Hanna-Barbera Cartoons, Inc.
(All Rights Reserved)
CREATORS
Butch Hartman, Eugene Mattos,
Michael Rann
DIRECTOR
Butch Hartman
LAYOUT DESIGNER
Bill Proctor
BACKGROUND STYLISTS
Tim Maloney, Leonard Robledo
EXECUTIVE PRODUCER
Buzz Potamkin
SUPERVISING PRODUCER
Larry Huber
Traditional cel animation.

3
The Rugrats, television series
STUDIO
Klasky Csupo, Inc., in association with
NICKELODEON © 1994 MTV Networks
(All Rights Reserved)
DESIGNERS
Gabor Csupo, Arlene Klasky,
Paul Germain
PRODUCERS
Geraldine Clark, Charles Swenson
ART DIRECTOR
Igor Koualyov
Traditional cel animation.

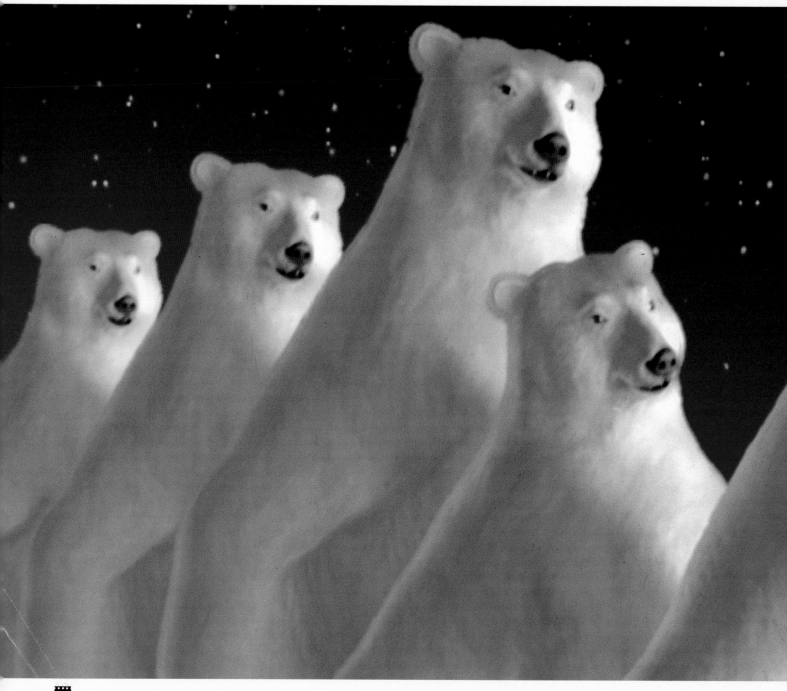

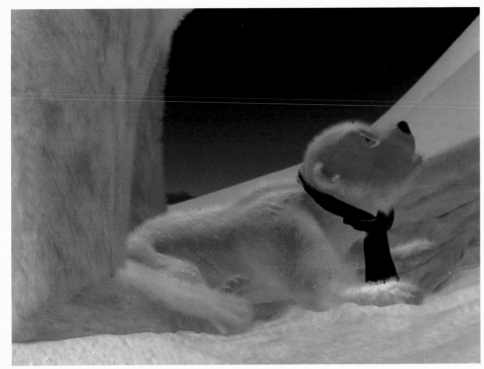

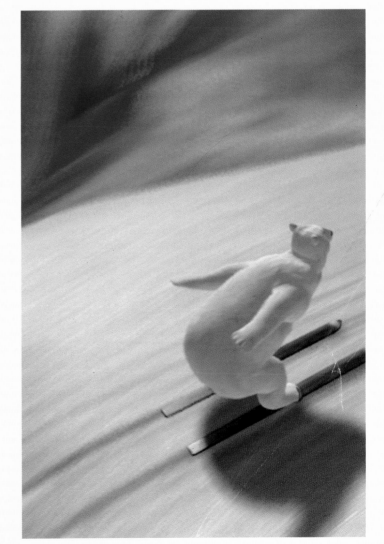

1-3
**Jump, Coca-Cola Polar Bears,
commercial**
STUDIO
**Rhythm & Hues, Inc./Sierra Hotel
productions**
DIRECTORS
Henry Anderson, Ken Stewart
PRODUCERS
Liz Ralston, Robert Parker
Traditional cel animation.

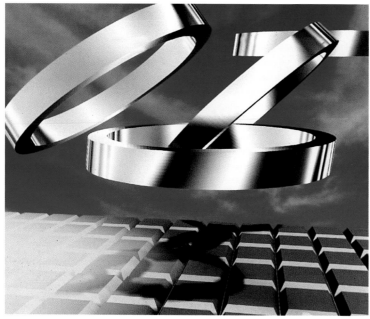

1

2

3

1-3
Audi, television advertisement
STUDIO
C.D.S. Video & Graphics
PRODUCTION COMPANY
C.D.S. Video & Graphics
SUPERVISOR/ANIMATOR
Ulisses R. Simionato
ART DIRECTOR
Ulisses R. Simionato
*Digital animation completed on a
486 DX2 computer.*

4
Navane, short film

STUDIO
Metamatic Studios

DESIGNER
Metamatic Studios

SUPERVISOR/DIRECTOR
Thomas Sacchi

ART DIRECTOR
Thomas Sacchi

DESIGNERS
Alex Colonna, Stevin Laino

*Digital animation created on an Amiga
2000 with Lightwave 3-D software.*

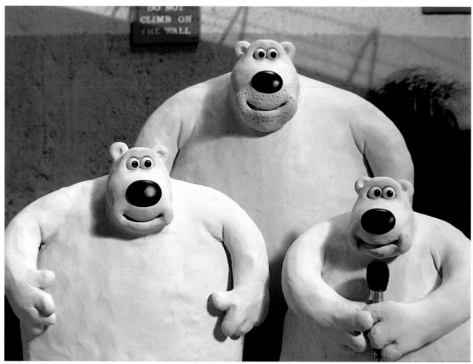

1
Creature Comforts, "The British Animation Invasion", short film
STUDIO
Ardman Animation Studios
ART DIRECTOR
Nick Park
DISTRIBUTOR
Expanded Entertainment
This Academy Award winner was created with clay animation.

2
Business School, computer game
STUDIO
Rhythm & Hues Studios, Inc.
DIRECTOR
Randy Roberts
ART DIRECTOR
Michael Brennecke
EXECUTIVE PRODUCERS
Lisa O'Brien, Michael Crapser
PRODUCERS
Ken Roupenian, Chuck Conner, Sande Breakstone
Digital animation.

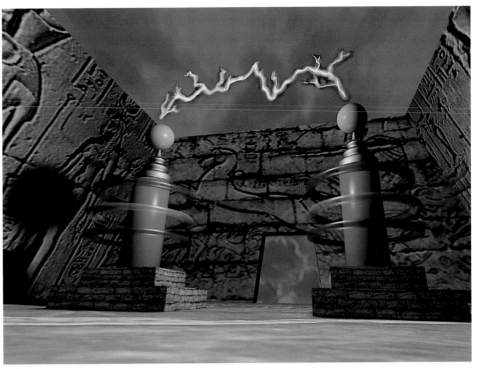

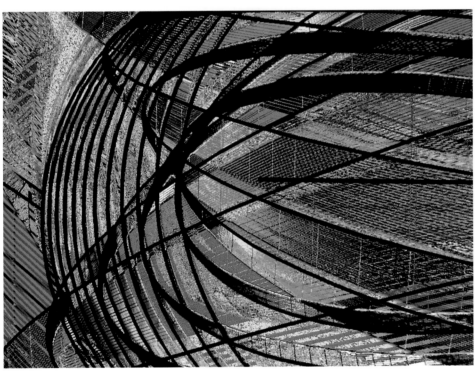

3
Windmills of My Mind

STUDIO
Electronic Visulization Lab

DESIGNER
Mihailo Alic

ALL DIRECTION
Mihailo Alic

*Real-time animation and digital
animation.*

4
Rites of passage, music video

STUDIO
Gregory MacNicol, Computer Graphics

DESIGNER
Gregory MacNicol

ALL DIRECTION
Gregory MacNicol

*Digital animation completed with
Autodesk 3-D studio software on
an IBM PC.*

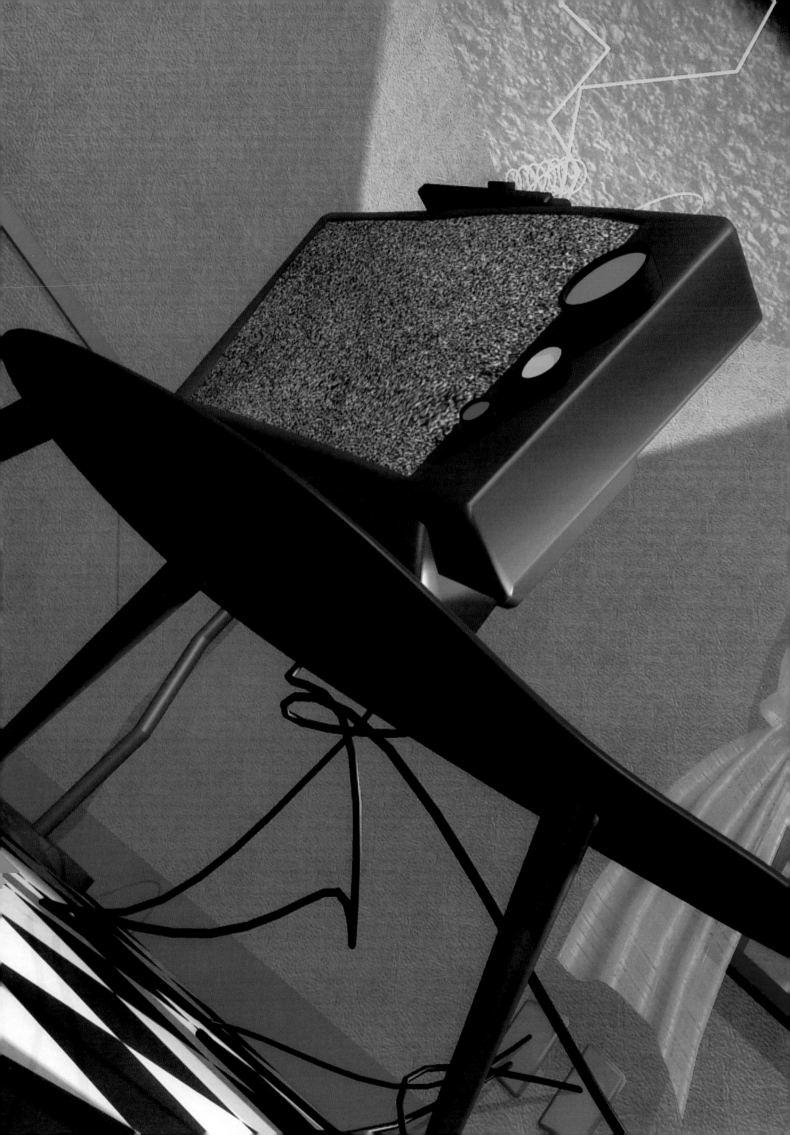

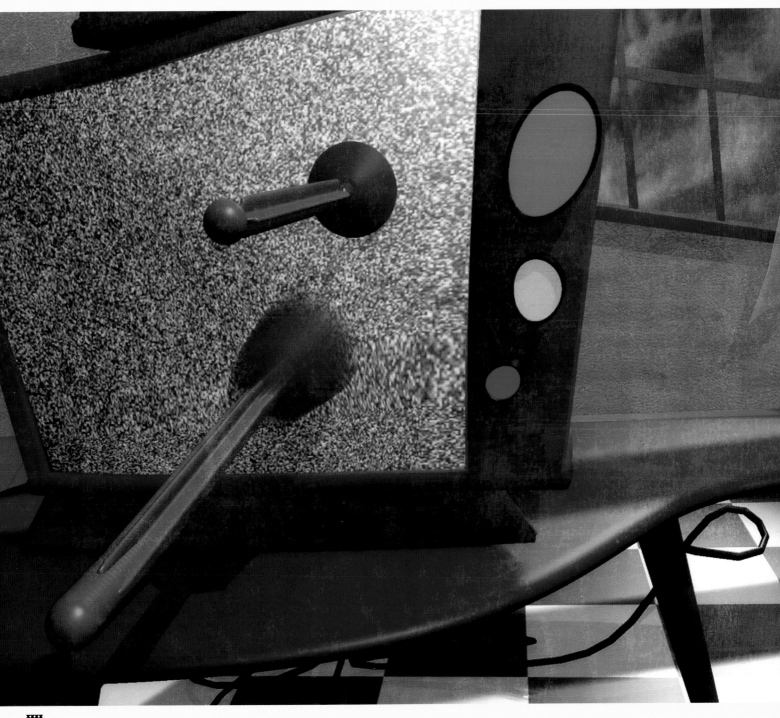

1
Buzz TV, multimedia production

PRODUCTION COMPANY
Skyline Displays, Inc.

DESIGNER
Charlie Breakiron

Digital animation created with Silicon Graphics Indigo Elan hardware and Softimage three-dimensional software.

2
Buzz TV 2, multimedia production

PRODUCTION COMPANY
Skyline Displays, Inc.

DESIGNER
Charlie Breakiron

Digital animation created with Silicon Graphics Indigo Elan hardware and Softimage three-dimensional software.

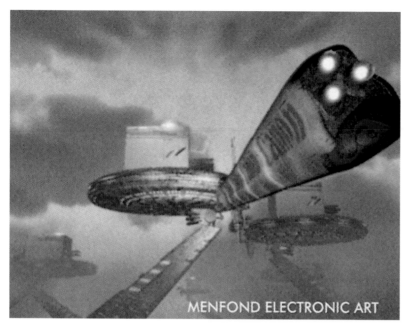

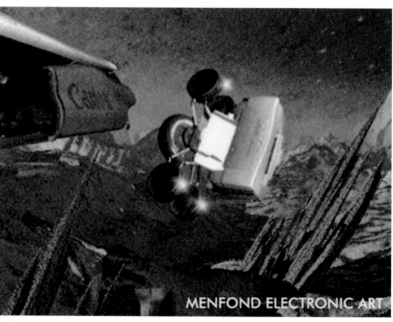

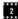

1-3
**Cannon Business Machine -
Space Ship**, television advertisement

STUDIO
**Menfond Electronic Art & Computer
Design Company Limited**

PRODUCTION COMPANY
**Menfond Electronic Art & Computer
Design Company Limited**

DESIGNER
Victor Wong

SUPERVISOR/ANIMATOR
Eddy Wong

ART DIRECTOR
Eddy Wong

EXECUTIVE PRODUCER
Thalia Tau

*Digital design created with Silicon
Graphics Indigo hardware and Alias
and Softimage software.*

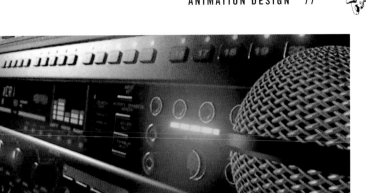

4-6
Samsung TVOK - Hi-Tech, television advertisement

STUDIO
Menfond Electronic Art & Computer Design Company Limited

PRODUCTION COMPANY
Menfond Electronic Art & Computer Design Company Limited

DESIGNER
Victor Wong

SUPERVISOR/ANIMATOR
Eddy Wong

ART DIRECTOR
Eddy Wong

EXECUTIVE PRODUCER
Thalia Tau

Digital design created with Silicon Graphics Indigo hardware and Alias and Softimage software.

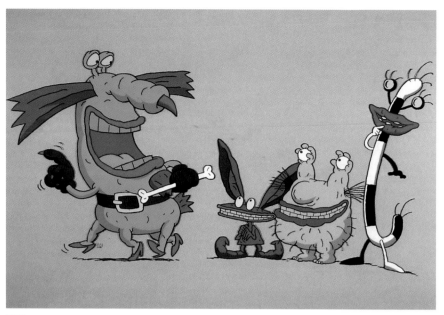

1

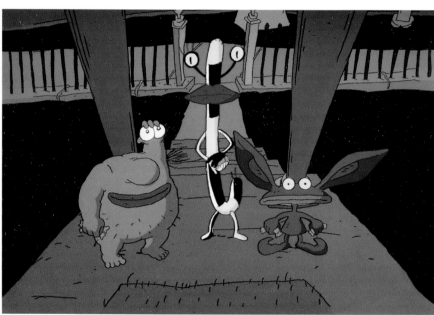

2

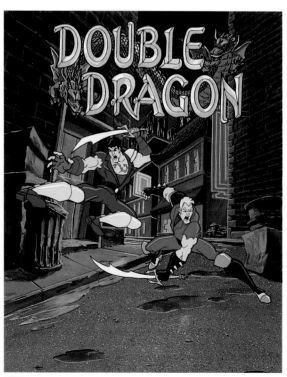

3

1-2
AAHHH! Real Monsters, television series

STUDIO
Klasky Csupo, Inc., in association with NICKELODEON © 1994 MTV Networks (All Rights Reserved)

DESIGNERS
Gabor Csupo, Peter Gaffney

EXECUTIVE PRODUCERS
Arlene Klasky, Gabor Csupo

ART DIRECTOR
Igor Koualyov

Traditional cel animation

3
Double Dragon, short film

STUDIO
DIC Entertainment

DESIGNER
DIC Entertainment

SUPERVISON/DIRECTOR
Chuck Patton

Traditional cel animation

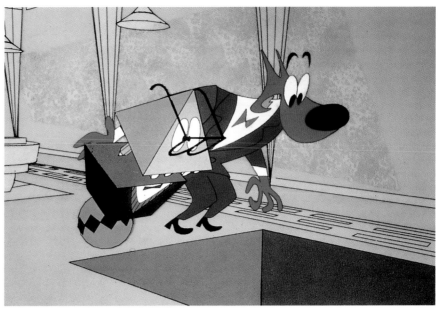

4

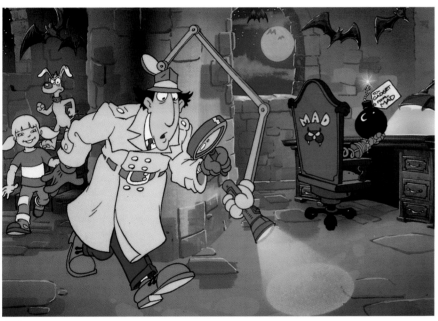

5

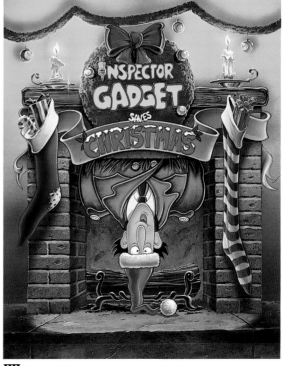

6

4
Technological Threat, short film
STUDIO
Kroyer Films, Inc.
DESIGNERS
Bill and Sue Kroyer
DISTRIBUTOR
Expanded Entertainment
Traditional cel and computer animation

5-6
**Inspector Gadget Saves Christmas,
short film**
STUDIO
DIC Entertainment
DESIGNER
DIC Entertainment
Traditional cel animation

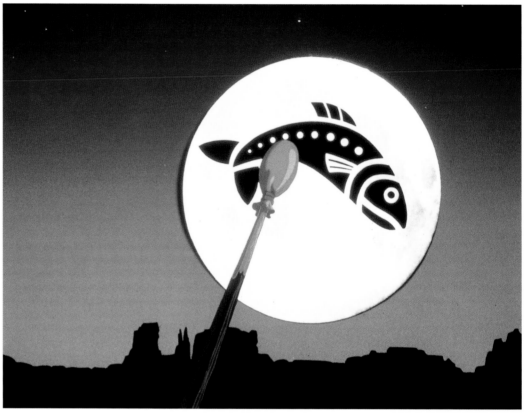

1

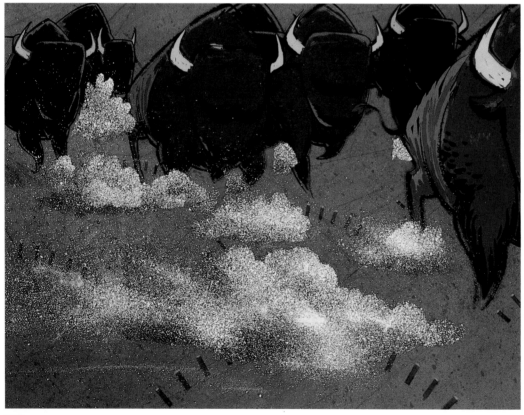

2

1-3
This Land is Your Land: Kids' Songs by Woody Guthrie, animated home video

STUDIO
© 1993 Calico Entertainment
(All Rights Reserved)

SUPERVISOR/DIRECTOR
Tom Burton

SUPERVISOR/ANIMATOR
Mary Cim

EXECUTIVE PRODUCERS
Lee Mann, Nora Guthrie

PRODUCERS
Tom Burton, Claudia Zeitlin Burton

ASSOCIATE PRODUCER
Diane De Laurentis

WRITER
Tom Burton

HEAD ANIMATORS
Burt Medall, Won Ki Cho, Hee Ja Cho, Mary Cim

PRODUCTION DESIGNERS
Ken Leonard, Curtis Cim, Dan Chesser, Nestor Redondo

Mixed media animation.

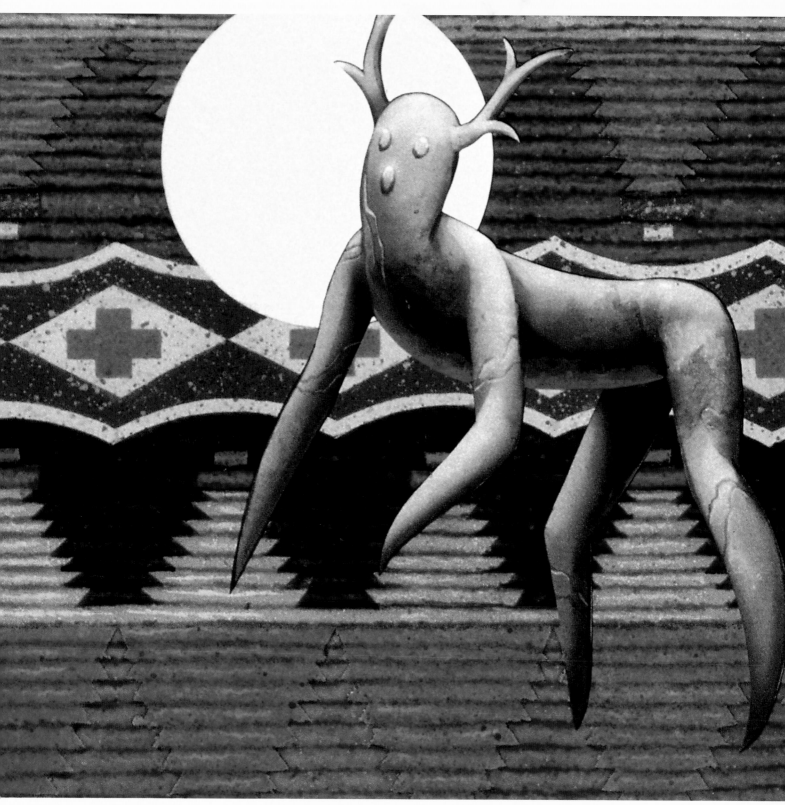

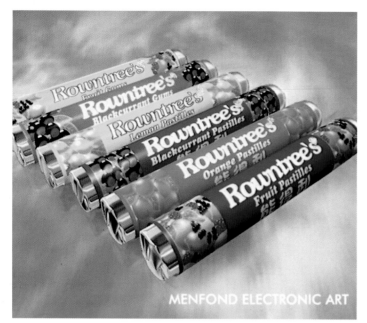

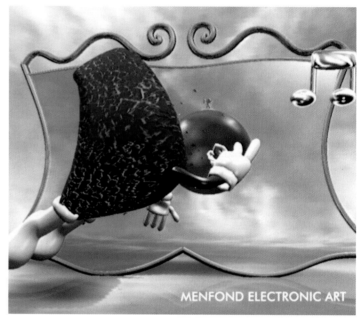

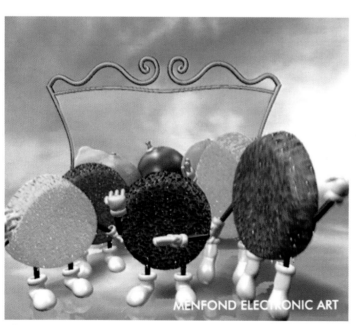

1-3
**Rowntree's Sweets - Mirror,
television advertisement**

STUDIO
**Menfond Electronic Art & Computer
Design Company Limited**

PRODUCTION COMPANY
**Menfond Electronic Art & Computer
Design Company Limited**

DESIGNER
Victor Wong

SUPERVISOR/ANIMATOR
Eddy Wong

ART DIRECTOR
Eddy Wong

EXECUTIVE PRODUCER
Thalia Tau

*Digital design created with Silicon
Graphics Indigo hardware and Alias
and Softimage software.*

4
**Go, Speed Racer, Go!,
limited edition litho art**

STUDIO
**The Tooniversal Company, Inc.
© and ™ 1994 Speed Racer
Enterprises, Inc.**

DESIGNER
Rossen Varbanov

SUPERVISOR/DIRECTOR
Ippei Kuri

SUPERVISOR/ANIMATOR
Ron Merk

ART DIRECTOR
Ippei Kuri

Traditional cel animation.

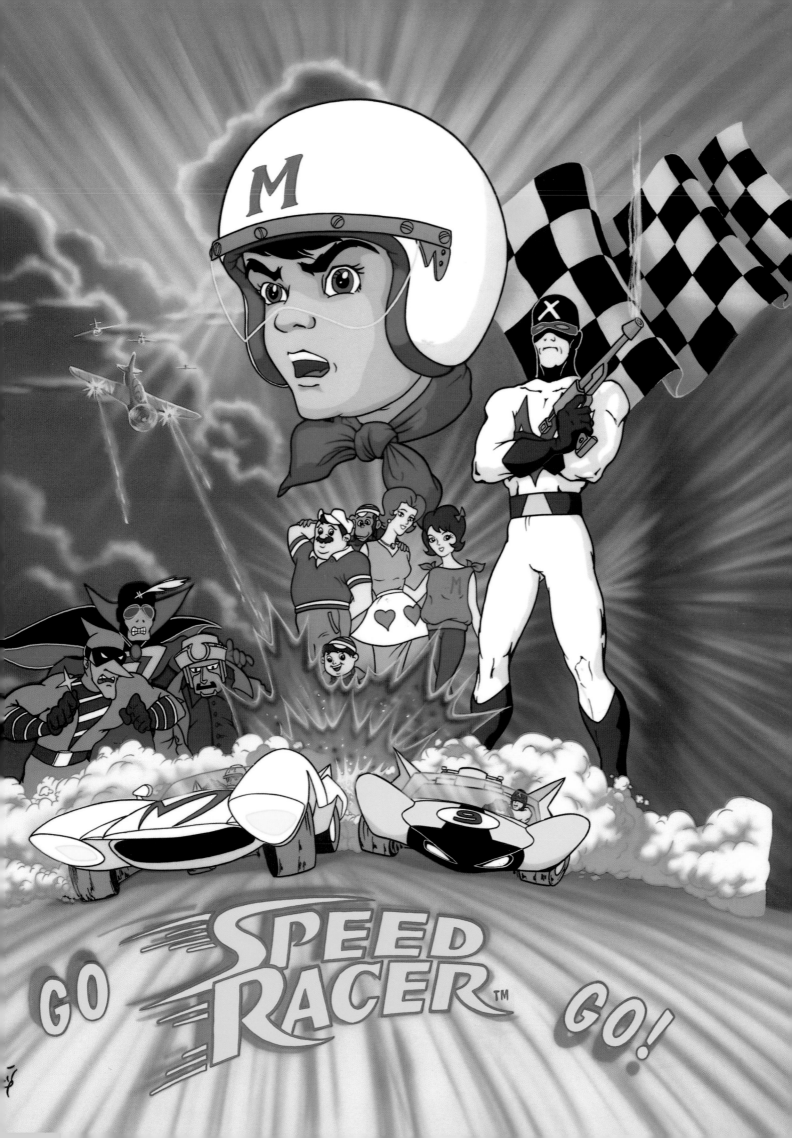

1

2

3

1-4
Something To Live For, television program promotion

STUDIO
WUSA TV Design Department

PRODUCTION COMPANY
WUSA TV Design Department

DESIGNER
Mary Ruesen Strauss

SUPERVISOR/ANIMATOR
Karen Swenholt

ART DIRECTOR
Mary Ruesen Strauss

PRODUCER
Paige Canaday

Digital animation created with Microtime DFX DLT.

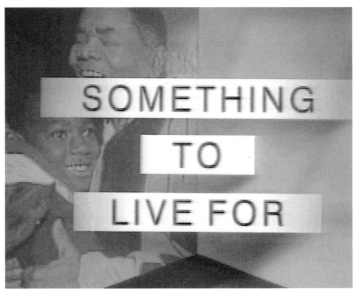

4

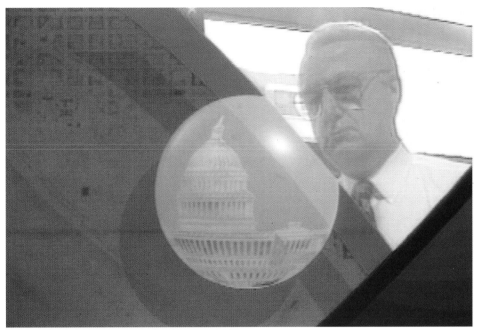

5

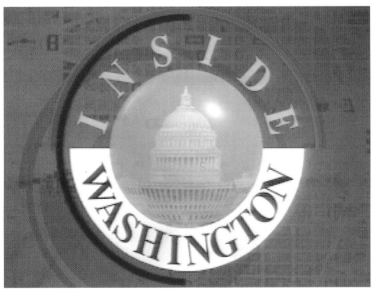

6

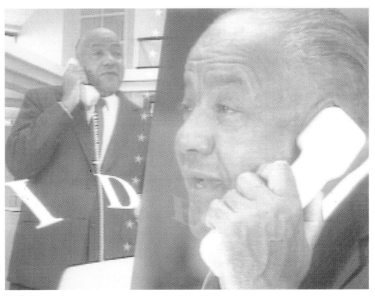

7

5-7
**Inside Washington,
television show opener**

STUDIO
WUSA TV Design Department

PRODUCTION COMPANY
WUSA TV Design Department

DESIGNER
Mary Ruesen Strauss

SUPERVISOR/ANIMATOR
Donna Beard

ART DIRECTOR
Mary Ruesen Strauss

THREE-DIMENSIONAL ANIMATOR
Scott Suess

*Digital animation created with
Microtime DFX DLT and Topas 3-D.*

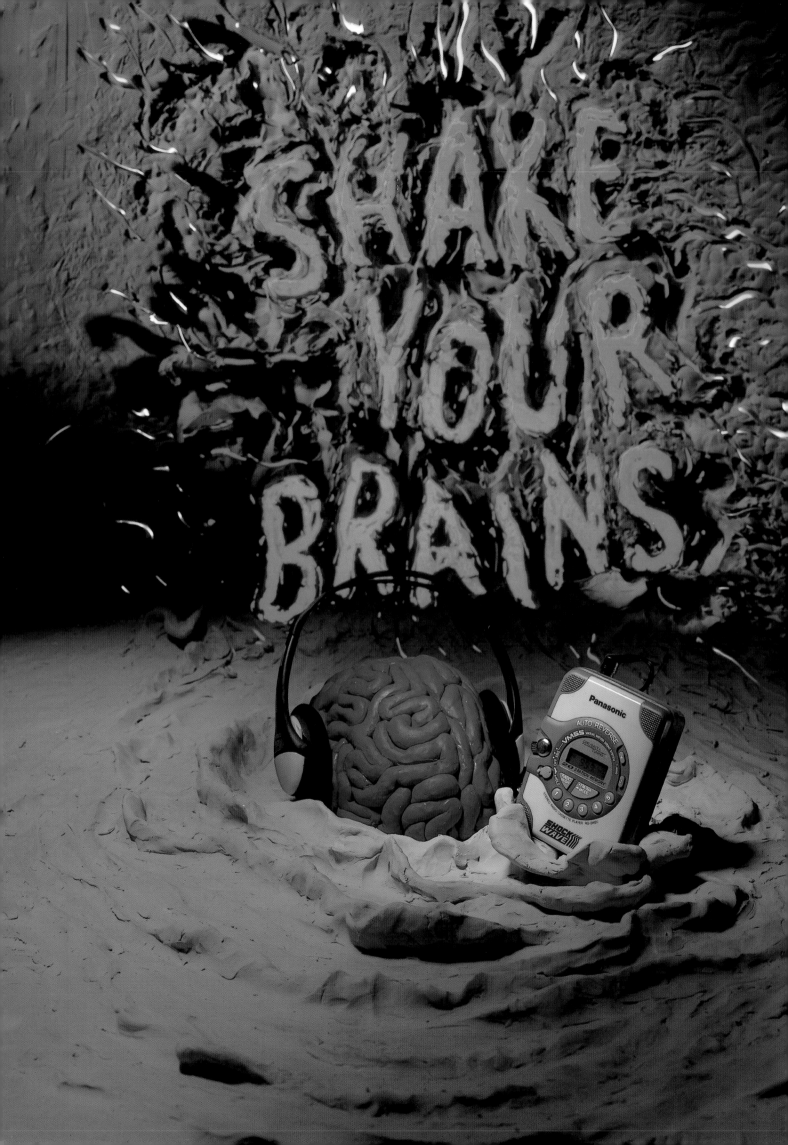

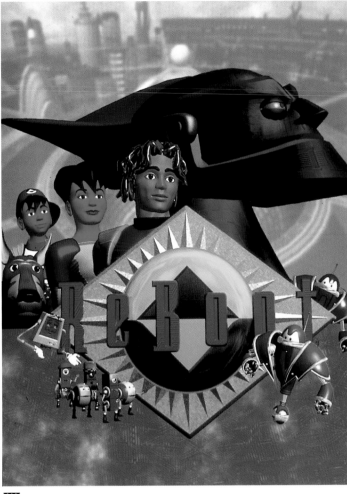

2-3
Reboot, television series
STUDIO
BLT Productions
DESIGNER
Chris Braugh, Alliance
PRODUCER
Chris Braugh, Alliance
Digital animation

1
Shake Your Brains (Panasonic), television advertisement

STUDIO
Cuppa Coffee Animation

SUPERVISOR/ANIMATOR
Steve Hillman

ART DIRECTOR
Bruce Alcock

PRODUCER
Adam Shaheen

STILLS/PRINT
Blair Robbins

CLIENT
DDB Needham, Panasonic

Clay animation: blue clay/plasticine was used as the "brain-matter," and a replacement technique was used with brains sculpted in various phases. The green background moved in waves, with stippled texture running through it.

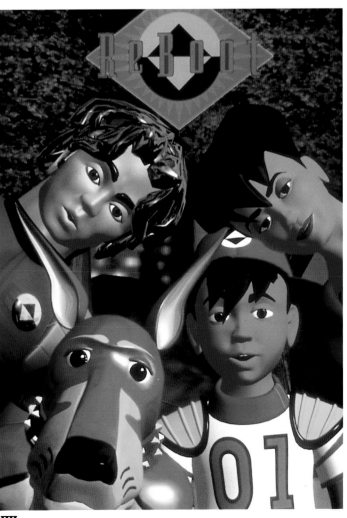

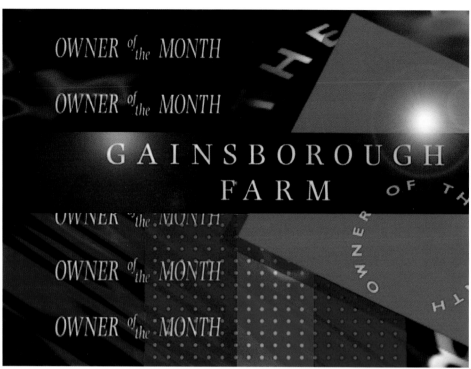

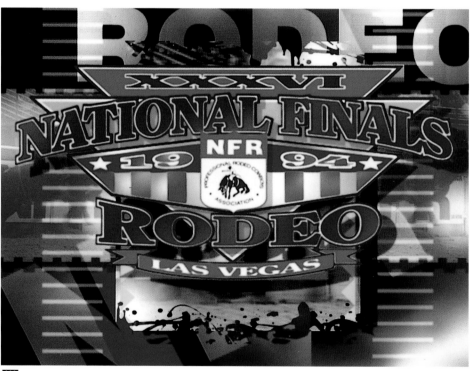

1
ESPN's Race Horse Digest (Gainsborough Farms, Owner of the Month), television special promotion

PRODUCTION COMPANY
Winner Communication, Inc.

SUPERVISOR/ANIMATOR
Frank Garner

ART DIRECTORS
Frank Garner, Dan Maras

DIRECTOR
David Newman

PRODUCER
David Bruner

Digital animation created with Quantel HAL software.

2
ESPN's NFR (National Finals Rodeo), television special promotion

PRODUCTION COMPANY
Winner Communication, Inc.

SUPERVISOR/ANIMATOR
Frank Garner

ART DIRECTORS
Frank Garner, Dan Maras

PRODUCER
Chris White

Digital animation created with Quantel HAL software.

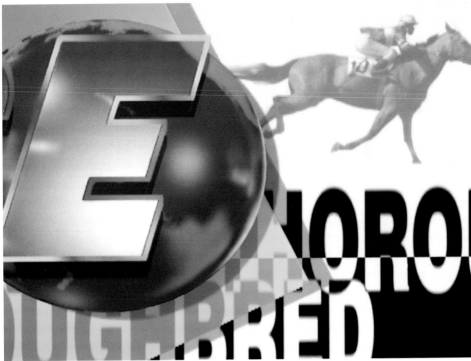

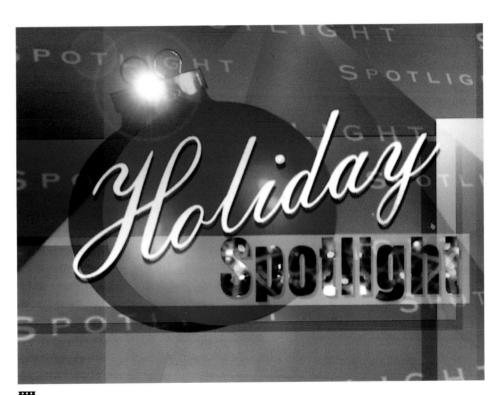

3
**ESPN's Race Horse Digest,
television series**

PRODUCTION COMPANY
Winner Communication, Inc.

SUPERVISOR/ANIMATOR
Frank Garner

ART DIRECTORS
Frank Garner, Dan Maras

CEO
Jim Wilburn

PRODUCER
David Bruner

DIRECTOR
David Newman

*Digital animation created with Quantel
HAL software.*

4
**Prevue Channel Holiday Spotlight,
television network promotion**

PRODUCTION COMPANY
Winner Communication, Inc.

SUPERVISOR/ANIMATOR
Frank Garner

ART DIRECTORS
Frank Garner, Dan Maras

CLIENTS
Kathy Murphey, Jim Gray

*Digital animation created with
Quantel HAL software.*

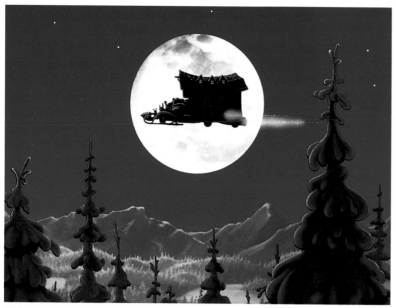

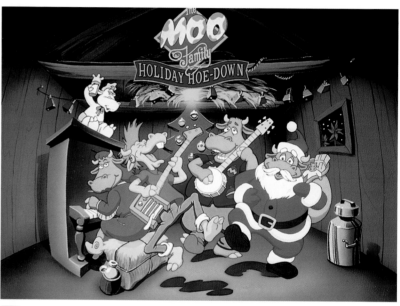

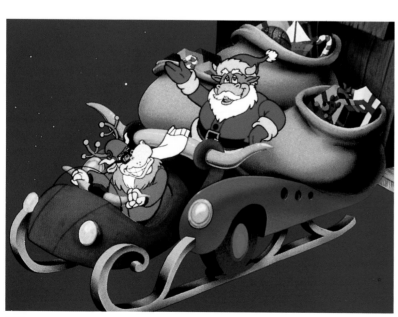

1-3
The Moo Family Holiday Hoe-Down,
half-hour animated special

STUDIO
©1992 Calico Entertainment
(All Rights Reserved)

DESIGNER
Tom Burton

SUPERVISOR/DIRECTOR
Tom Burton

SUPERVISORS/ANIMATORS
Burt Medall, Won Ki Cho, Mary Cim,
Hee Ja Cho

ART DIRECTOR
Ken Leonard

EXECUTIVE PRODUCERS
Lee Mann, Stanford Blum

PRODUCERS
Tom Burton, Claudia Zeitlin Burton

ASSOCIATE PRODUCER
Diane De Laurentis

WRITERS
Tom Burton, Marc Handler

HEAD ANIMATORS
Burt Medall, Won Ki Cho, Hee Ja Cho,
Mary Cim

PRODUCTION DESIGN
Ken Leonard, Curtis Cim, Dan Chesser,
Nestor Redondo

SYNDICATOR/NETWORK/CABLE
Bohort Entertainment

Traditional cel animation and digital
animation.

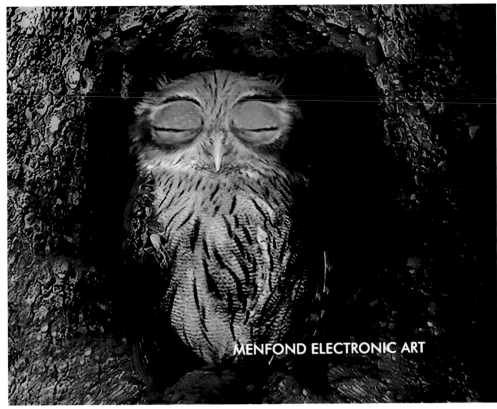

MENFOND ELECTRONIC ART

4

4-5
Carrier - Snail, Bee, Owl, television advertisement

STUDIO
Menfond Electronic Art & Computer Design Company Limited

PRODUCTION STUDIO
Menfond Electronic Art & Computer Design Company Limited

DESIGNER
Victor Wong

SUPERVISOR/ANIMATOR
Eddy Wong

ART DIRECTOR
Eddy Wong

EXECUTIVE PRODUCER
Thalia Tau

Digital design created with Silicon Graphics Indigo hardware and Alias and Softimage software.

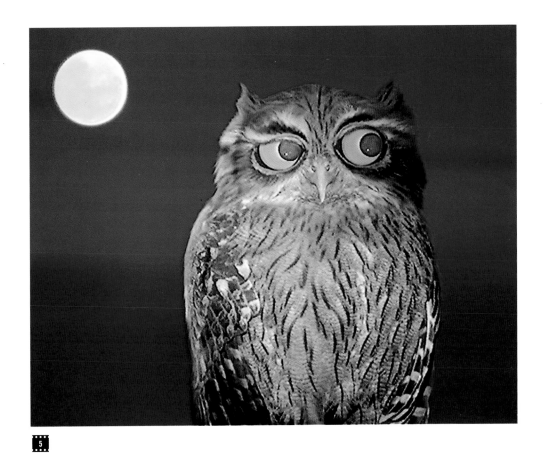

5

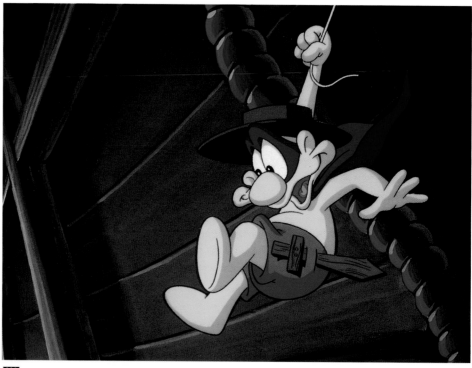

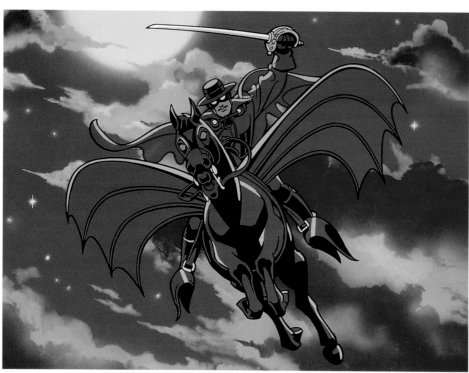

1
The Mr. Bogus Show, animated special

STUDIO
**Zodiac Entertainment/Calico
Entertainment**

SUPERVISOR/DIRECTOR
Tom Burton

ART DIRECTOR
Ken Leonard

EXECUTIVE PRODUCER
Peter Keefe

PRODUCERS
Tom Burton, Claudia Zeitlin Burton

DIRECTOR
Tom Burton

SYNDICATOR/NETWORK/CABLE
© Zodiac Entertainment

Traditional cel animation.

2
Zorro, half-hour animated series

STUDIO
**© Calico/IFI in association with
Zorro Productions, Inc.
(All Rights Reserved)**

DESIGNER
Nestor Redondo

SUPERVISOR/DIRECTOR
Tom Burton

ART DIRECTOR
Ken Leonard

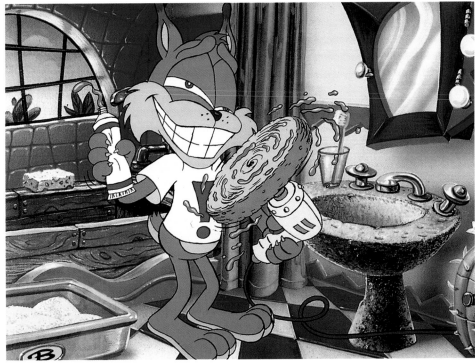

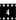

3-4

Bubsy: What Could Possibly Go Wrong?, half-hour animated special

STUDIO
Calico Entertainment/Imagination Factory

SUPERVISOR/DIRECTOR
Tom Burton

SUPERVISORS/ANIMATORS
Burt Medall, Won Ki Cho, Mary Cim, Hee Ja Cho

ART DIRECTOR
Ken Leonard

EXECUTIVE PRODUCERS
Lee Mann, Stanford Blum, John A.S. Skeel (Accolade, Inc.)

PRODUCERS
Tom Burton, Claudia Zeitlin Burton

ASSOCIATE PRODUCER
Diane De Laurentis

WRITER
Ray De Laurentis

HEAD ANIMATORS
Burt Medall, Won Ki Cho, Hee Ja Cho, Mary Cim

PRODUCTION DESIGNERS
Ken Leonard, Curtis Cim, Dan Chesser, Nestor Redondo

SYNDICATOR/NETWORK/CABLE
Bohort Entertainment, © 1993 Accolade, Inc. (All Rights Reserved)

Traditional cel animation.

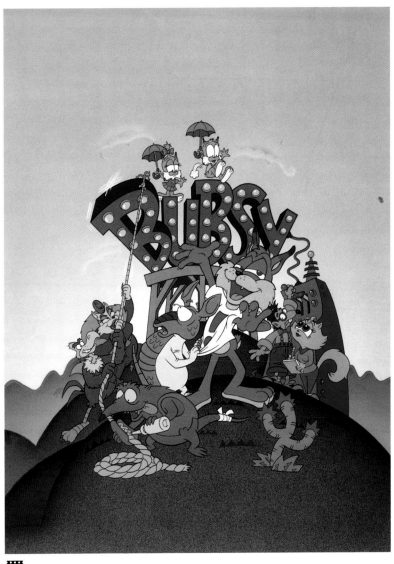

DUCKMAN

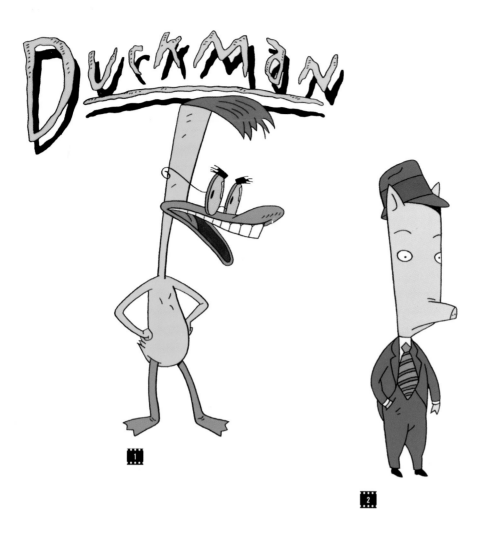

1

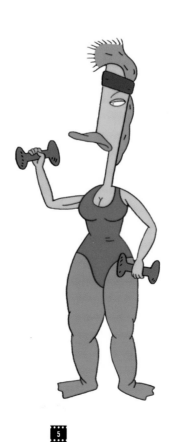

2

3

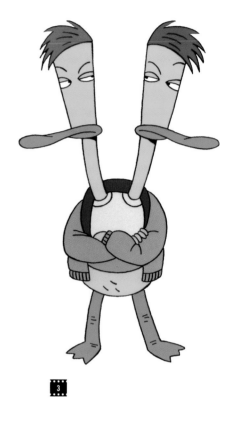

4

5

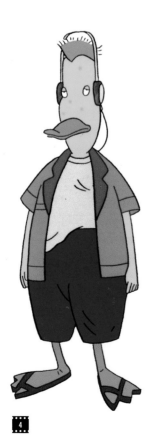

1-8
Duckman, animated prime-time television series

STUDIO
Klasky Csupo, Inc., in association with Reno and Osborn productions and Paramount Television © 1994 Paramount Pictures (All Rights Reserved)

DESIGNER
Everett Peck

EXECUTIVE PRODUCERS
Arlene Klasky, Gabor Csupo, Jeff Reno, Ron Osborn

Traditional cel animation.

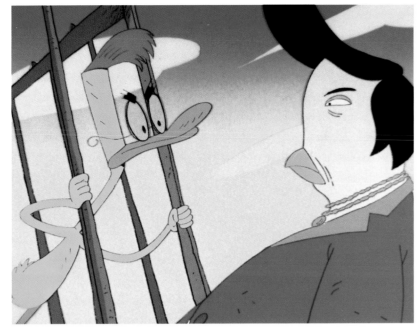

6

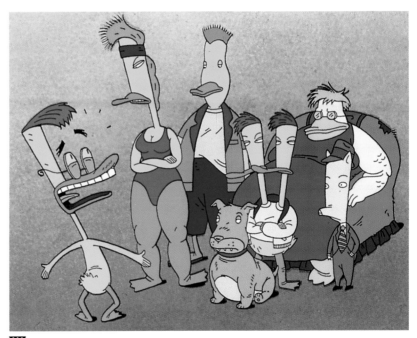

7

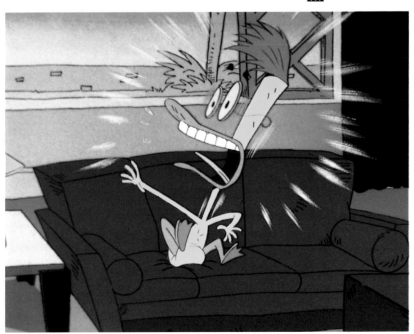

8

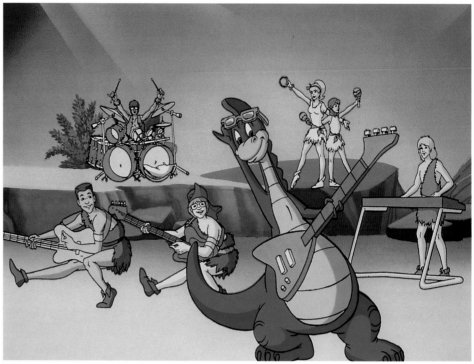

1

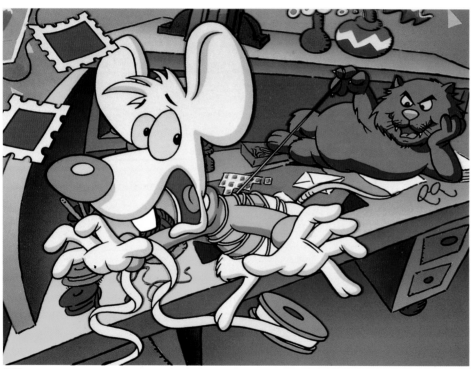

2

1
**Denver, The Last Dinosaur, half-hour
animated series**

STUDIO
© W.E.P., Calico Entertainment

SUPERVISOR/DIRECTOR
Tom Burton

2
**This Land Is Your Land: Kids' Songs
by Woody Guthrie, animated special
and home video**

STUDIO
© 1992 Calico Entertainment
(All Rights Reserved)

SUPERVISOR/DIRECTOR
Tom Burton

SUPERVISORS/ANIMATORS
**Burt Medall, Won Ki Cho, Mary Cim,
Hee Ja Cho**

Traditional cel animation.

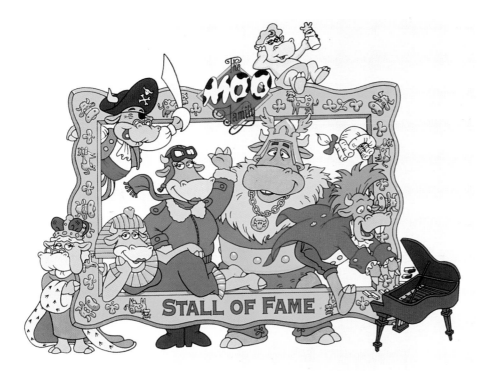

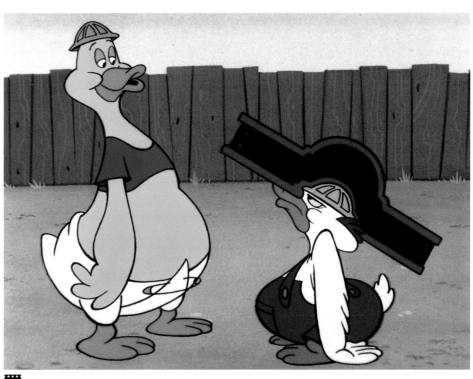

3
**The Moo Family Stall of Fame,
half-hour animated special**
STUDIO
**© 1993 Calico Entertainment
(All Rights Reserved)**
DESIGNER
Tom Burton
SUPERVISOR/DIRECTOR
Tom Burton
SUPERVISORS/ANIMATORS
**Burt Medall, Won Ki Cho, Mary Cim,
Hee Ja Cho**
ART DIRECTOR
Ken Leonard
Traditional cel animation.

4
The Baby Huey Show, short film
STUDIO
**Harvey Famous studios/Carbunkle
Cartoons**
DESIGNER
Harvey Comics
SUPERVISOR/DIRECTOR
Bob Jacques
SUPERVISOR/ANIMATOR
Kelly Armstrong
EXECUTIVE PRODUCER
Jeffrey A. Montgomery
Traditional cel animation.

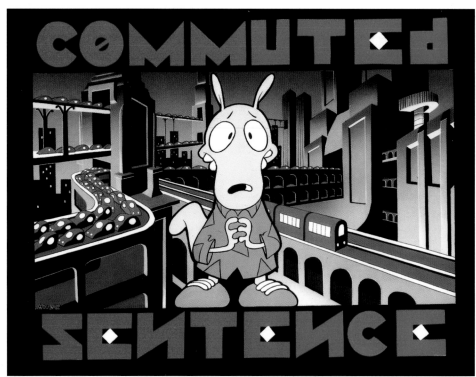

1

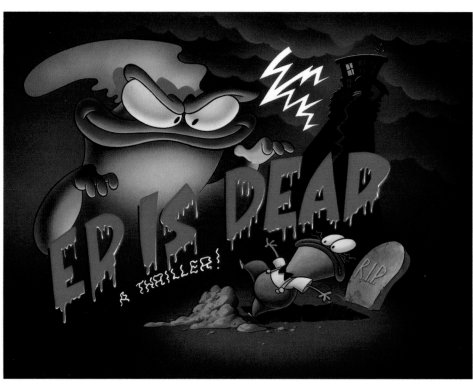

2

1
Rocko's Modern Life™, television
series
STUDIO
Games Animation, Inc.
© 1994 NICKELODEON
(All Rights Reserved)
DESIGNER
Joe Murray
SUPERVISOR/ANIMATOR
Chris Savino
ART DIRECTOR
Jeff Marsh
BACKGROUND PAINTER
Adriana Galvez
Traditional cel animation.

2
Rocko's Modern Life™, television
series
STUDIO
Games Animation, Inc.
© 1994 NICKELODEON
(All Rights Reserved)
DESIGNER
Joe Murray
SUPERVISOR/ANIMATOR
Chris Savino
ART DIRECTOR
Tim Berglund
BACKGROUND PAINTER
Tim Barnes
Traditional cel animation.

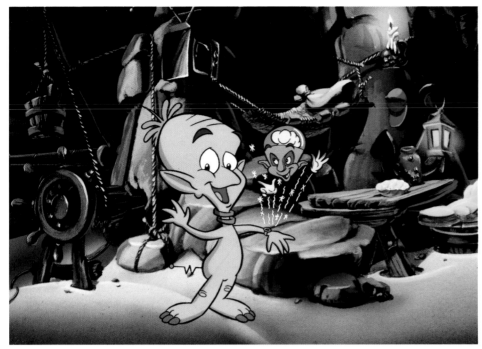

3
Widget, half-hour animated series
STUDIO
Zodiac Entertainment, Calico Entertainment
SUPERVISOR/DIRECTOR
Tom Burton
ART DIRECTOR
Ken Leonard
EXECUTIVE PRODUCER
Peter Keefe
PRODUCERS
Tom Burton, Claudia Zeitlin Burton
SYNDICATOR/NETWORK/CABLE
™Zodiac Entertainment
Traditional cel animation.

4
Twinkle, The Dream Being, half-hour animated series
STUDIO
Zodiac Entertainment, Calico Entertainment
SUPERVISOR/DIRECTOR
Tom Burton
ART DIRECTOR
Ken Leonard
EXECUTIVE PRODUCER
Peter Keefe
PRODUCERS
Tom Burton, Claudia Zeitlin Burton
DIRECTOR
Claudia Zeitlin Burton
SYNDICATOR/NETWORK/CABLE
**Zodiac Entertainment,
© MBC Production Co. Ltd.**
Traditional cel animation.

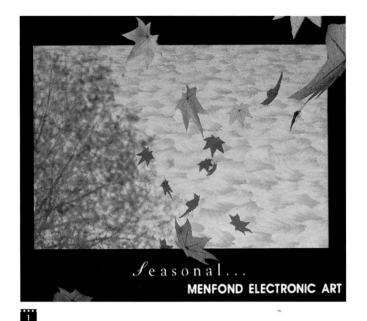

Seasonal...
MENFOND ELECTRONIC ART

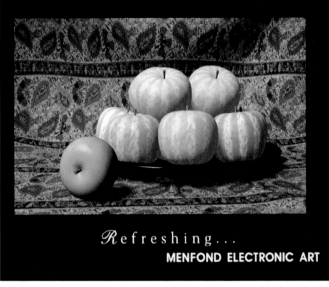

Refreshing...
MENFOND ELECTRONIC ART

Natural...
MENFOND ELECTRONIC ART

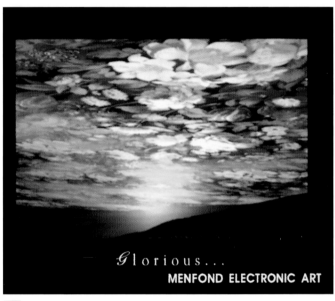

Glorious...
MENFOND ELECTRONIC ART

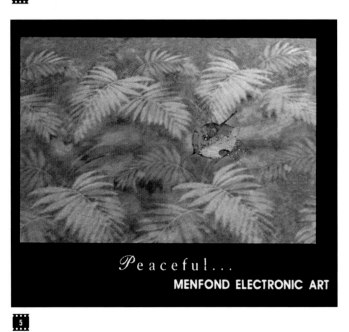

Peaceful...
MENFOND ELECTRONIC ART

1-5
Sunray Wallcoverings - Pictures of Living, television advertisement

STUDIO
Menfond Electronic Art & Computer Design Company Limited

PRODUCTION COMPANY
Menfond Electronic Art & Computer Design Company Limited

DESIGNER
Victor Wong

SUPERVISOR/ANIMATOR
Eddy Wong

ART DIRECTOR
Eddy Wong

EXECUTIVE PRODUCER
Thalia Tau

Digital design created with Silicon Graphics Indigo hardware and Alias and Softimage software.

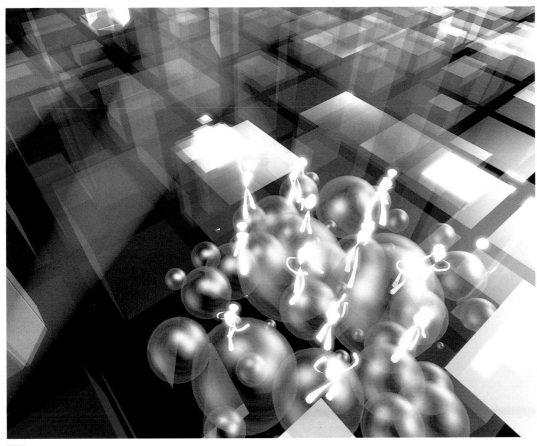

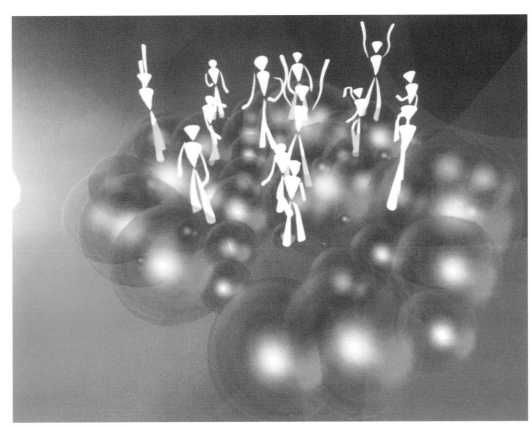

6-7
Bretnic (Cromatic), music video
STUDIO
Cat Zentrum
CHARACTER/CREATOR/DESIGNER
Stefan Sonntag
SUPERVISOR/ANIMATOR
Stefan Sonntag
ART DIRECTOR
Stefan Sonntag
PRODUCER
Jo Atze

*Digital animation completed on a
Pentum-90 PC with Autodesk 3-D
studio software.*

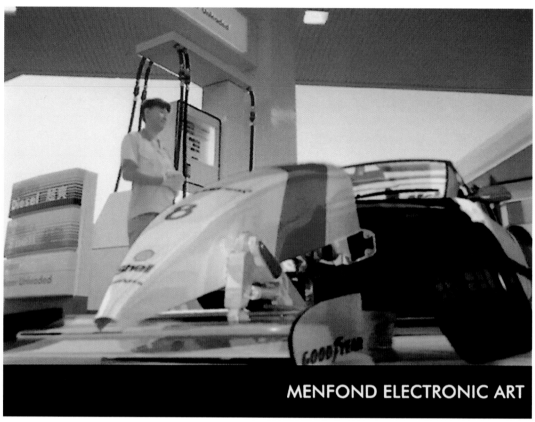

MENFOND ELECTRONIC ART

1

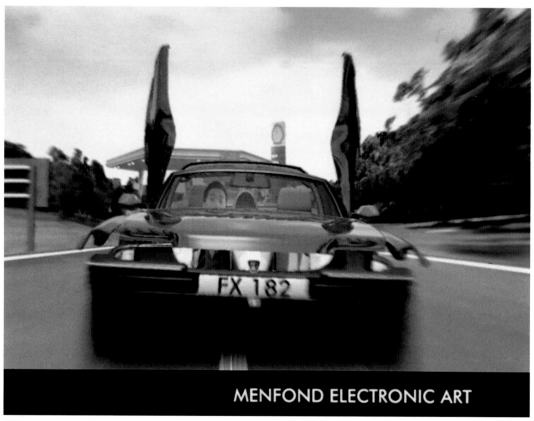

FX 182

MENFOND ELECTRONIC ART

2

1-4
Shell Card - Formula, television advertisement
STUDIO
Menfond Electronic Art & Computer Design Company Limited
PRODUCTION COMPANY
Menfond Electronic Art & Computer Design Company Limited
DESIGNER
Victor Wong
SUPERVISOR/ANIMATOR
Eddy Wong
ART DIRECTOR
Eddy Wong
EXECUTIVE PRODUCER
Thalia Tau

Digital design created with Silicon Graphics Indigo hardware and Alias and Softimage software.

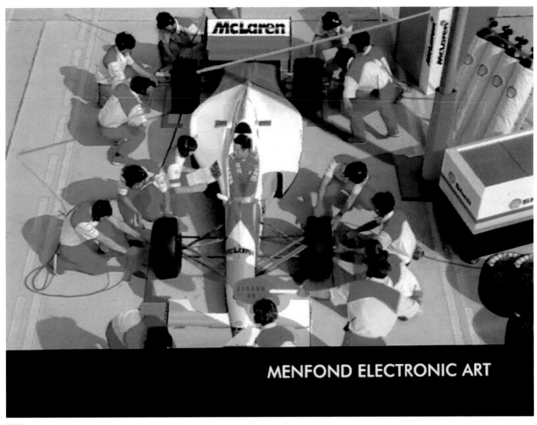

3

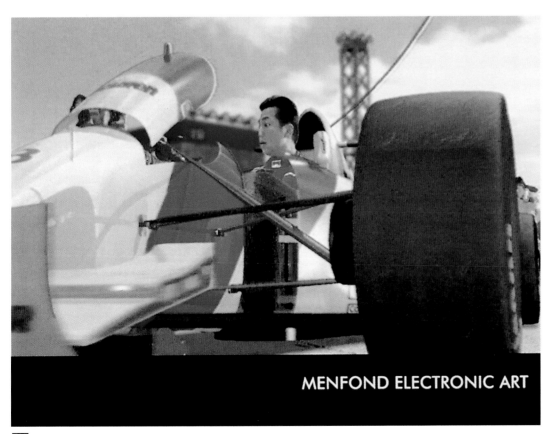

4

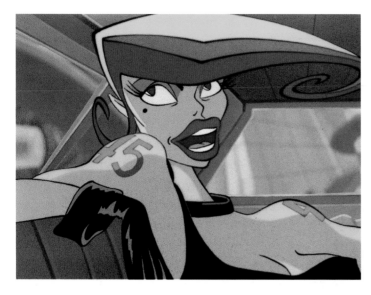

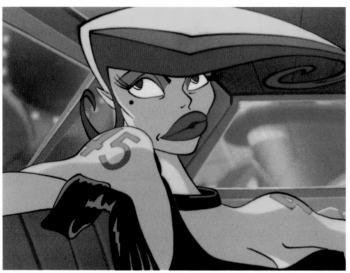

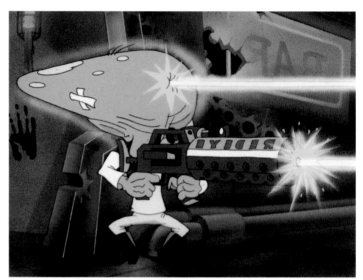

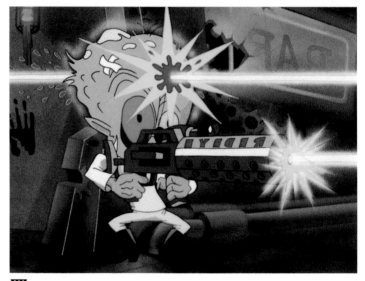

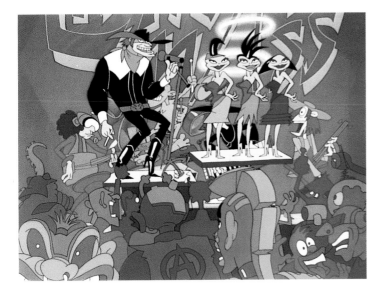

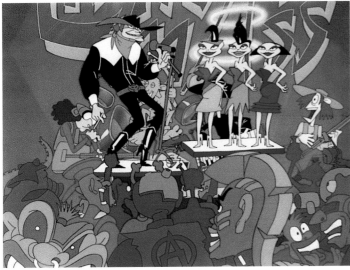

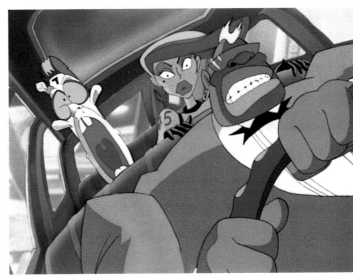

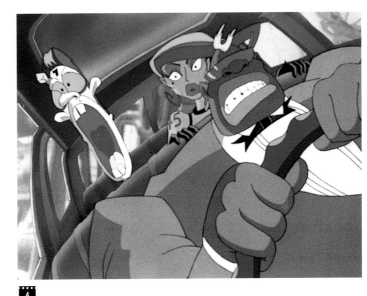

1-4
Collet. 45, short film

STUDIO
Ravenwood Pictures

DESIGNER
Joe Pearson

SUPERVISOR/DIRECTOR
Joe Pearson

SUPERVISOR/ANIMATOR
Vladimar Goncherov

ART DIRECTORS
Joe Pearson, Nikolai Koshkin

PRODUCERS
Joe Pearson, Jeff Marsh

Hand-inked and painted animation.

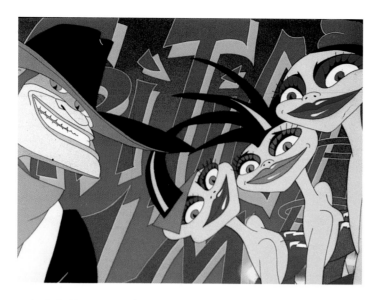

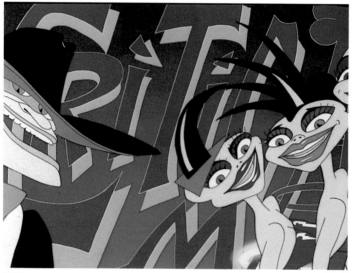

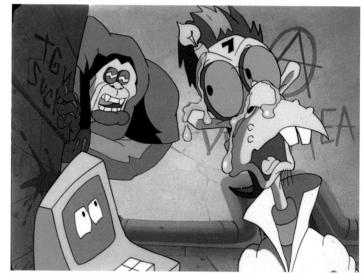

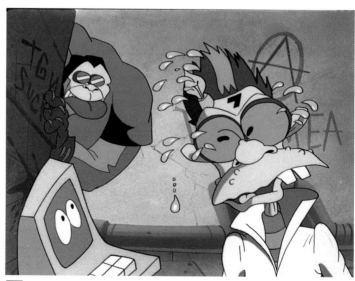

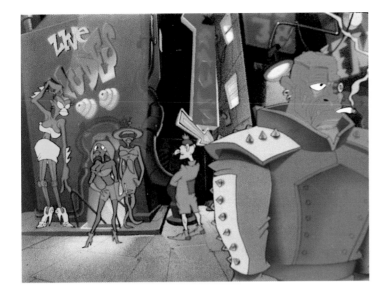

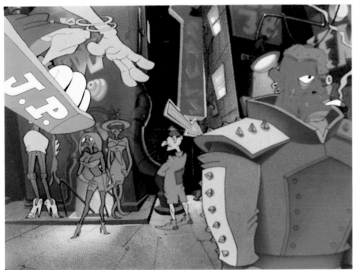

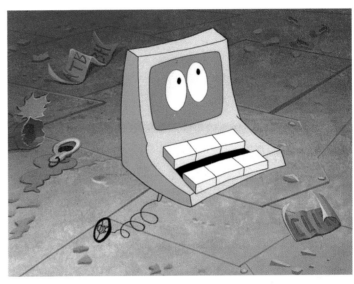

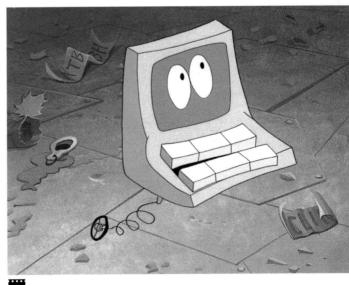

1-4

Collet. 45, short film

STUDIO
Ravenwood Pictures

DESIGNER
Joe Pearson

SUPERVISOR/DIRECTOR
Joe Pearson

SUPERVISOR/ANIMATOR
Vladimar Goncherov

ART DIRECTORS
Joe Pearson, Nikolai Koshkin

PRODUCERS
Joe Pearson, Jeff Marsh

Hand-inked and painted animation.

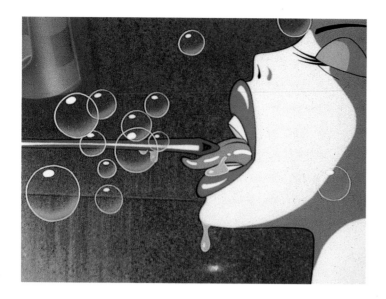

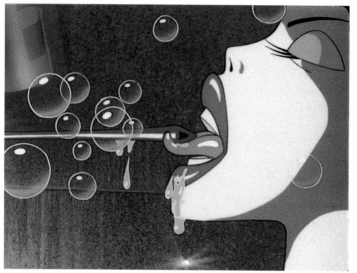

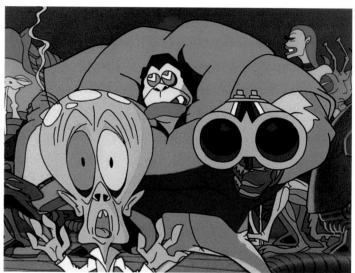

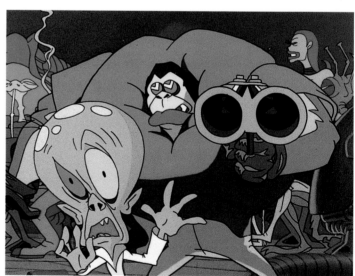

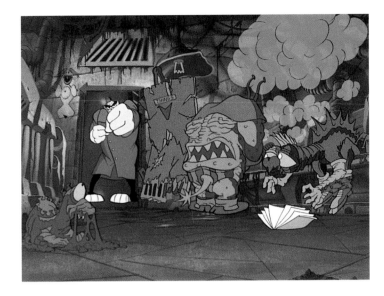

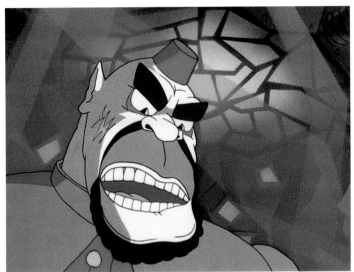

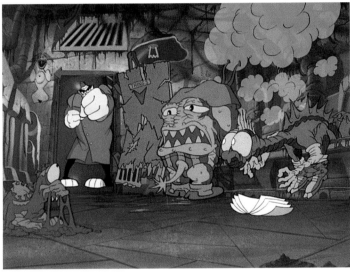

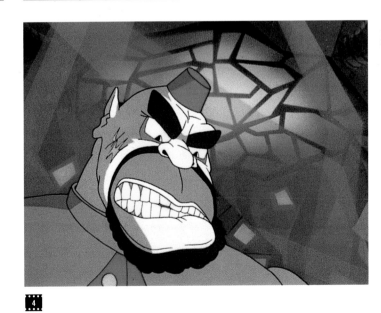

1-4
Collet. 45, short film

STUDIO
Ravenwood Pictures

DESIGNER
Joe Pearson

SUPERVISOR/DIRECTOR
Joe Pearson

SUPERVISOR/ANIMATOR
Vladimar Goncherov

ART DIRECTORS
Joe Pearson, Nikolai Koshkin

PRODUCERS
Joe Pearson, Jeff Marsh

Hand-inked and painted animation.

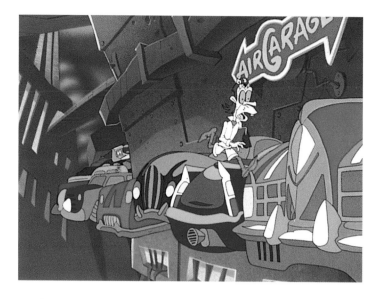

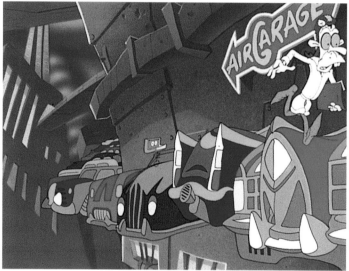

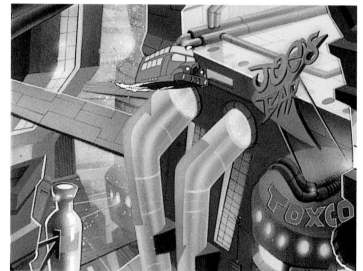

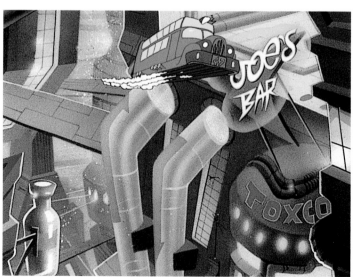

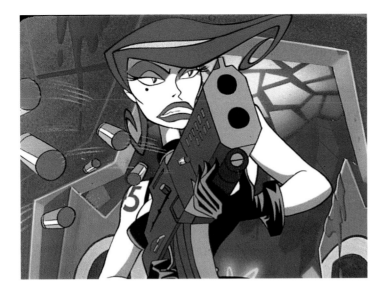

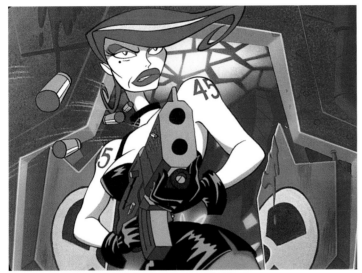

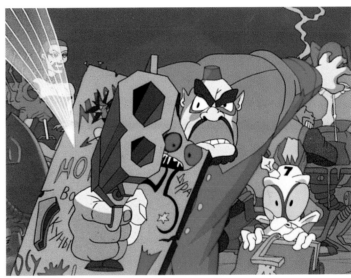

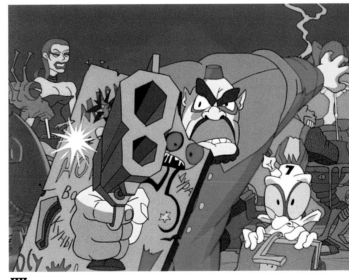

1-4
Collet. 45, short film
STUDIO
Ravenwood Pictures
DESIGNER
Joe Pearson
SUPERVISOR/DIRECTOR
Joe Pearson
SUPERVISOR/ANIMATOR
Vladimar Goncherov
ART DIRECTORS
Joe Pearson, Nikolai Koshkin
PRODUCERS
Joe Pearson, Jeff Marsh
Hand-inked and painted animation.

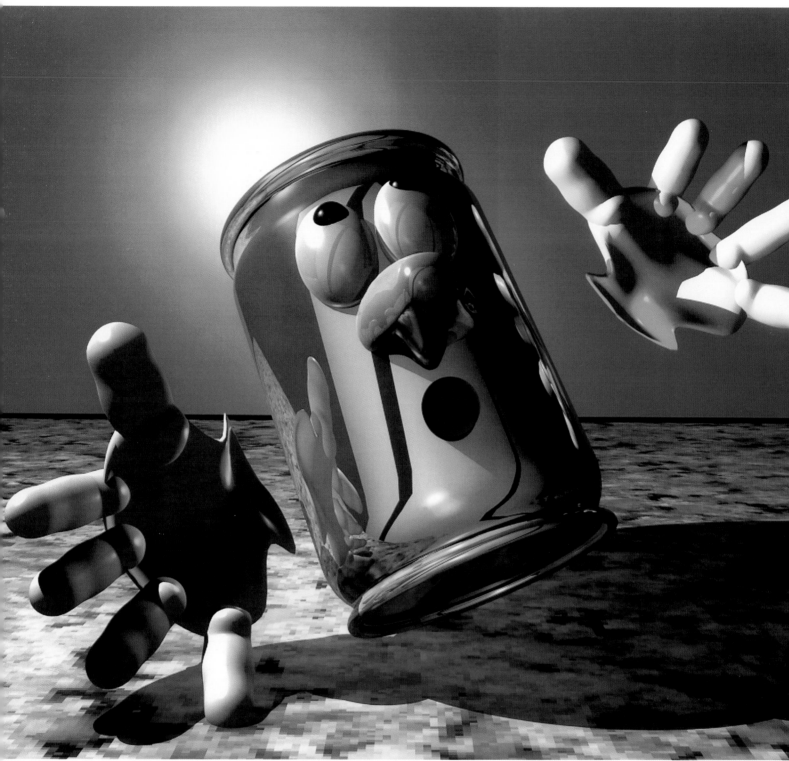

(Previous page)
3D Animation, multimedia production
PRODUCTION COMPANY
Skyline Displays, Inc.
DESIGNER
Charlie Breakiron
*Digital animation created with Silicon
Graphics Indigo Elan hardware and
Softimage three-dimensional software.*

1
MT Can, demonstration reel
PRODUCTION COMPANY
Skyline Displays, Inc.
DESIGNER
Charlie Breakiron
*Digital animation created with Silicon
Graphics Indigo Elan hardware and
Softimage three-dimensional software.*

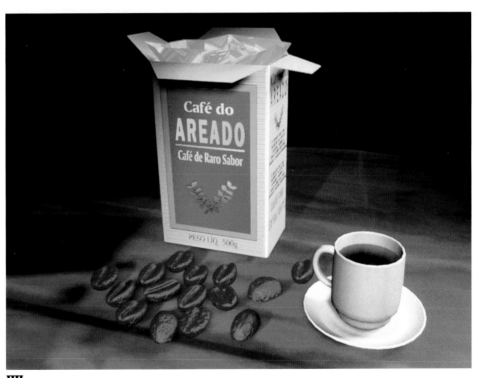

2
**Suncrunchers "Standing Tall",
computer game**
STUDIO
Rhythm & Hues Studios, Inc.
DIRECTOR
Clark Anderson
EXECUTIVE PRODUCERS
Lisa O'Brien, Michael Crapser
PRODUCER
Kristina Hamm
PRODUCER
Alex Abramowicz
Digital animation.

3
Areado Coffee, short film
STUDIO
MS Studio
DESIGNER
Mauro Heitor
SUPERVISOR/ANIMATOR
Marcelo Ferr
ART DIRECTOR
Mauro Heitor
*Animation created and rendered on an
IBM PC 486 DX2 66. Map textures and
final adjustments made in Fractal
Design Painter 3 software.*

1

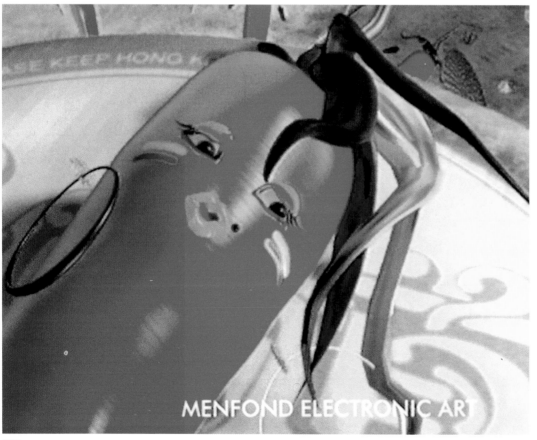

2

1-4
**Spicy Cup Noodle (Nissin),
television advertisement**

STUDIO
**Menfond Electronic Art & Computer
Design Company Limited**

PRODUCTION COMPANY
**Menfond Electronic Art & Computer
Design Company Limited**

DESIGNER
Victor Wong

SUPERVISOR/ANIMATOR
Eddy Wong

ART DIRECTOR
Eddy Wong

EXECUTIVE PRODUCER
Thalia Tau

*Digital design created with Silicon
Graphics Indigo hardware and Alias
and Softimage software.*

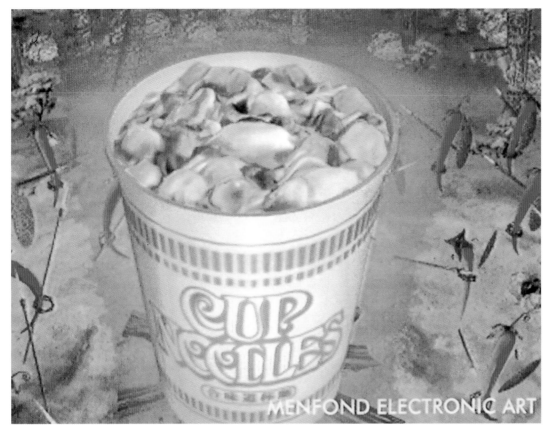

MENFOND ELECTRONIC ART

3

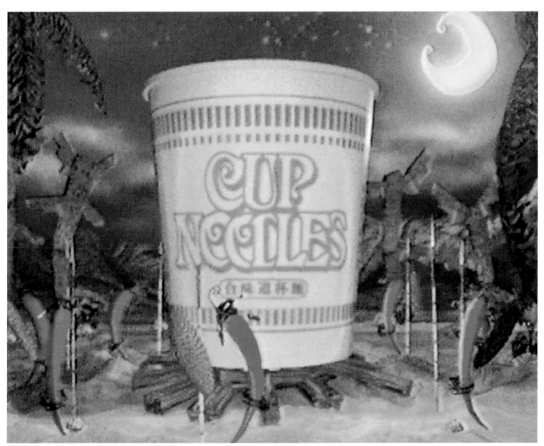

4

INDEX

DIRECTORY

Ardman Animation Studios
c/o Expanded Entertainment
28024 Dorothy Drive
Agoura Hills, CA 91301

Bear Spots Inc.
30 Atlantic Avenue
Toronto, ONT M6K 1X8
CANADA

BLT Productions
c/o SSA P.R.
16027 Ventura Blvd, #206
Encino, CA 91436

Calico Entertainment
Calico Creations, Ltd.
9340 Eton Avenue
Chatsworth, CA 91311-5879

Calico Entertainment/Imagination
Factory
Calico Creations, Ltd.
9340 Eton Avenue
Chatsworth, CA 91311-5879

Calico/IFI in association with Zorro
Productions, Inc.
Calico Creations, Ltd.
9340 Eton Avenue
Chatsworth, CA 91311-5879

Cat Zentrum
Heinrich-Vogl-Str 14
81479 Munich
GERMANY

Chechoslovak Film Export
c/o Expanded Entertainment
28024 Dorothy Drive
Agoura Hills, CA 91301

Cuppa Coffee Animation
401 Richmond Street W, Suite 351
Toronto, ONT M5V 1X3
CANADA

C.D.S. Video & Graphics
Rua Caraibas 642
Perdizes-Sao Paulo
CEP 05020
BRAZIL

DIC Entertainment
303 N Glenoaks Boulevard
Burbank, CA 91502

Electronic Visualization Lab
1539 Cricket Club #204
Orlando, FL 32828

Film Roman
12020 Chandler Boulevard, Suite 200
N. Hollywood, CA 91607

Michel Gagne
2355 N Sparks Street
Burbank, CA 91504

Games Animation, Inc.
4040 Vineland Avenue, Suite 105
Studio City, CA 91604

Games Production
NICKELODEON
1515 Broadway, 21st Floor
New York, NY 10036

Gaumont Multimedia
c/o SSA P.R.
16027 Ventura Blvd, #206
Encino, CA 91436

Gensler & Associates
2500 Broadway, Suite 300
Santa Monica, CA 90404

Gavrilo Gnatovich
c/o Expanded Entertainment
28024 Dorothy Drive
Agoura Hills, CA 91301

Hanna-Barbera Cartoons, Inc.
3400 Cahuenga Boulevard
Hollywood, CA 90068

ISC Lab–Pratt Institute
c/o Felipe Lara
202 Dean
Brooklyn, NY 11217

Jumbo Pictures
NICKELODEON
1515 Broadway, 21st Floor
New York, NY 10036

Kentucky Educational Television
600 Cooper Drive
Lexington, KY 40502-2296

Klasky Csupo, Inc.
1258 N Highland Avenue
Hollywood, CA 90038

Kroyer Films, Inc.
c/o Expanded Entertainment
28024 Dorothy Drive
Agoura Hills, CA 91301

Gregory MacNicol, Computer Graphics
732 Chestnut
Santa Cruz, CA 95060

Marina Productions
c/o SSA P.R.
16027 Ventura Blvd, #206
Encino, CA 91436

Menfond Electronic Art & Computer Design
Company Limited
Suite B&C, 18/F, Lockhart Centre,
301-307 Lockhart Road
HONG KONG

Metamatic Studios
2070 67th Street
Brooklyn, NY 11204

MS Studio
Rua Joao Borges 38/101, Gavea
Rio de Janeiro CEP 22451-100
BRAZIL

Nelvana Limited
32 Atlantic Avenue
Toronto, ONT M6K 1X8
CANADA

Rhythm & Hues Studios, Inc.
910 N Sycamore Avenue
Hollywood, CA 90038

Royal Collage of Art
c/o Expanded Entertainment
28024 Dorothy Drive
Agoura Hills, CA 91301

Semicolon II Grafix
16-44 Nonhyun Kangnam
Seoul 135-010
KOREA

Sierra Hotel Productions
13490 Firth Drive
Beverly Hills, CA 90210

Skyline Displays, Inc.
12345 Portland Avenue
Burnsville, MN 55337-1585

Aaron Smith & Will Panganiban
c/o Expanded Entertainment
28024 Dorothy Drive
Agoura Hills, CA 91301

Spumco, Inc.
5625 Melrose Avenue
Los Angeles, CA 90038

Take One Productions
101 Pheasant Wood Court
Morrisville, NC 27560

The Tooniversal Company, Inc.
6319 De Soto Avenue, Suite 405
Woodland Hills, CA 91367

Winner Communication, Inc.
6120 South Yale
Tulsa, OK 74136-4229

WUSA TV Design Department
4100 Wisconsin Avenue NW
Washington, DC 20006
202-895-5479

W.E.P., Calico Entertainment
Calico Creations, Ltd.
9340 Eton Avenue
Chatsworth, CA 91311-5879

Zodiac Entertainment/Calico Entertainment
Calico Creations, Ltd.
9340 Eton Avenue
Chatsworth, CA 91311-5879

University of Zurich, Institute of Informatics
Loewenstrasse 9
8953 Dietikon
SWITZERLAND